Layered Impressions

A Poetic Approach to Mixed-Media Painting

Katie Kendrick

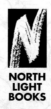

NORTH
LIGHT
BOOKS

Cincinnati, Ohio
www.createmixedmedia.com

Contents

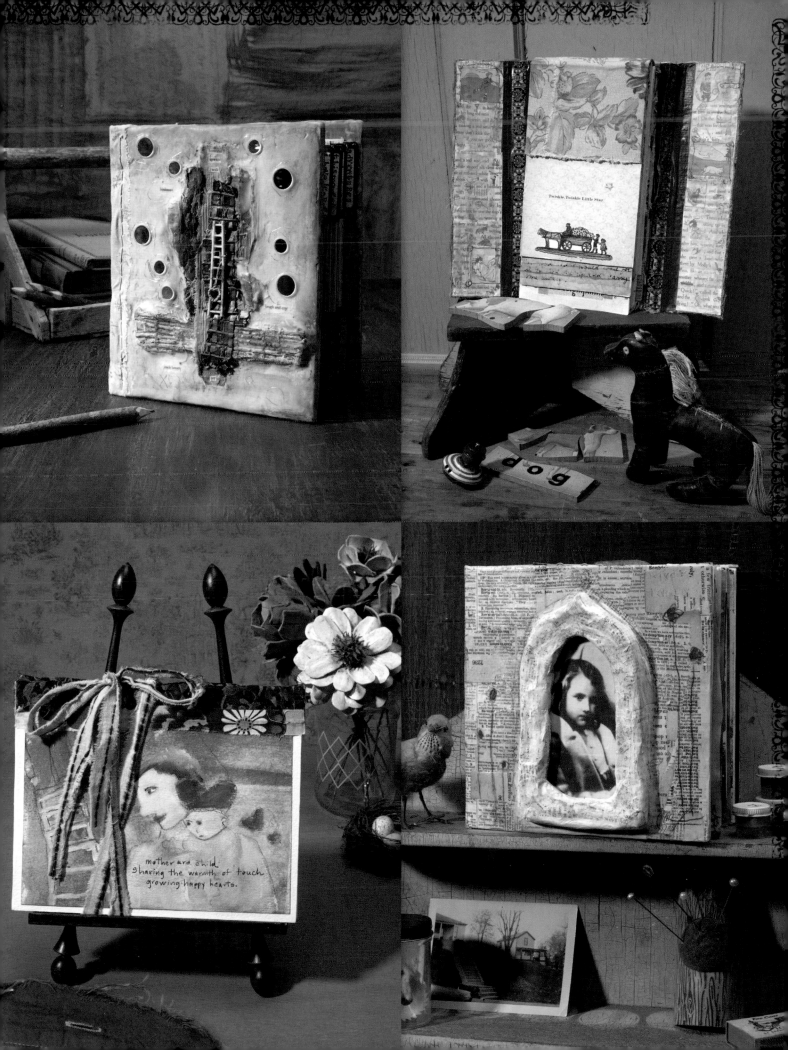

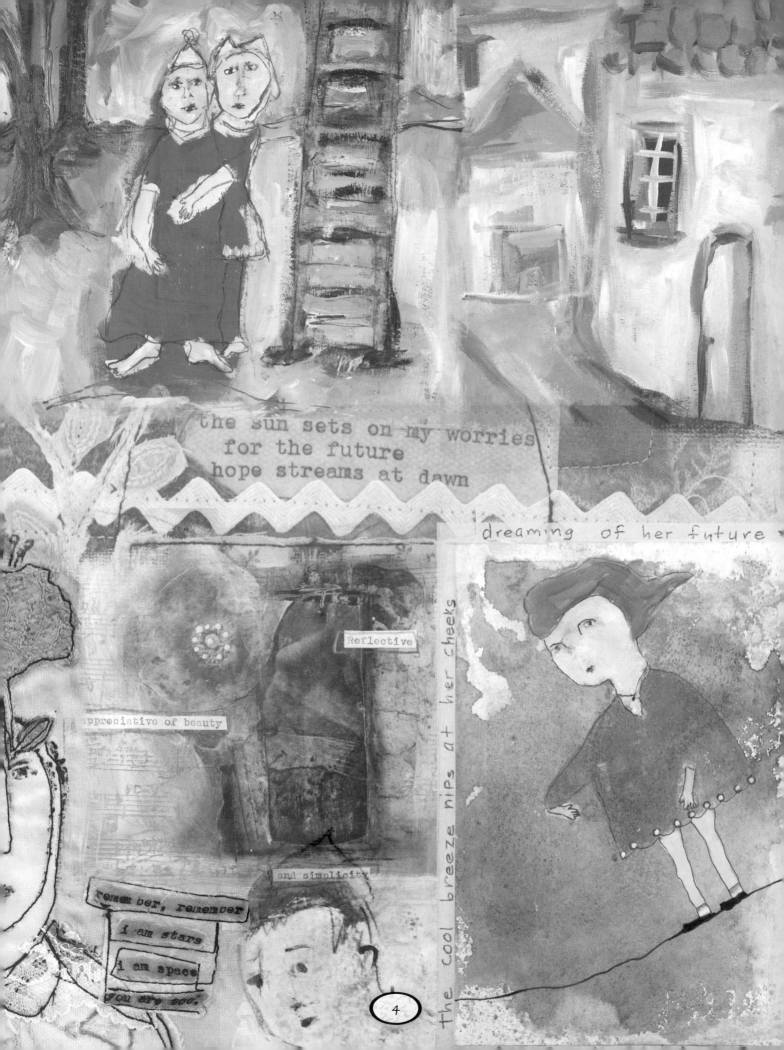

the sun sets on my worries
for the future
hope streams at dawn

dreaming of her future

Reflective

appreciative of beauty

and simplicity

remember, remember
i am stars
i am space
you are too.

the cool breeze nips at her cheeks

The Poetry of Life and Art

I wrote this book as a way to share my creative process with others. One of my favorite things to do as an artist is to spend time with fellow artists and observe how they create, whether it be in a class, in the studio or through a book. We each approach the creative process in our own unique way, and there is much we can learn from one another. I hope that this book is a bit like taking a class with me, hearing my voice in the words and watching my hands move through the photographs as I lead you along, step-by-step.

I've shared a variety of projects with you here, from flat paintings to three-dimensional artwork. Some of the pieces will call for a more intuitive approach, and in those cases I make some suggestions on ways to move forward and through possible obstacles along the way. Other projects are more straightforward and easily reproduced by following directions in each consecutive step.

For the painting projects, my goal is to demonstrate ways of seeing and creating, and to share specific techniques to aid in that process. In one project, you'll create by working with contrast, using collage and paint to build and change facial features with light, medium and dark values. In another project, I demonstrate how to use your inspiration from another artist's work to identify elements and moods to enhance your own creative process.

I will guide you as you create a mixed-media painting using tools other than your paintbrush; you will experiment with nondominant hand painting, finger painting and mark making.

You'll have instructions for making several different books using combinations of cardboard, plaster and encaustic medium. You'll learn how to make signatures using found and new materials, to create pages made of fabric and paper, and to combine a number of materials in a personal and meaningful way.

In one of the projects, you'll use your own personal symbols as the focus of a mixed-media painting experiment, in the end extracting smaller sections of the painting and featuring them in a dimensional wall hanging, now pieces that hang, turn and swivel.

You'll have directions to make a soulful doll with a papier mâché head, to hand paint a face and to sew a soft woolly body on it.

At the end of each project, you will find a Poetic Purpose—a "giving back" suggestion. Sharing your art, poetry and talent is a way for you to further expand the creative direction of each project, shifting the focus from creating for personal pleasure to sharing your creative spirit with family, friends and community. Random acts of kindness not only feel good, but are catching as well. By your own example, you touch the hearts of those around you, encouraging others to "pay it forward." We can work together to create a kinder and more generous world.

My sincere hope is that you experience this book in the fullest intention it was created, that as you journey along through your art-making process, you experience more clarity and depth, and hear the sound of your own authentic voice more clearly. May you feel increasing moments of connection to the dynamic flow—the creative spirit that connects each of us to one another, and all of us to life.

Supplies to Gather

There are some very basic supplies that you will use in all of the projects in this book, including palette paper (I make my own pad; see page 14), a water container and a paint cloth—a soft, used T-shirt is perfect for this. Some of the projects can get messy, so you might also want a pack of baby wipes and a roll of paper towels nearby. Having a few extra jars or small containers for mixing paint is a good idea, and since I don't usually wear latex gloves when I work (maybe you will), I wear a hand barrier cream sold in the art supply store. It protects my hands and makes cleaning much easier. Finally, you may want to cover your table with brown paper or plastic.

What follows are some specifics about the other supplies and tools we'll be using here and there throughout the book. While I've mentioned my favorites, feel free to substitute your own and use whatever inspires you.

Substrates

I love using recycled surfaces for substrates, and some of my favorites include cardboard, matboard, foam core, wallpaper, heavy vintage record covers, book covers and heavy file folders. If it's durable enough to take wet media, I'll use it. For new materials, I like 140-lb. (300 gsm) hot-press watercolor paper and printmaking paper.

Adhesives and Tape

Gel medium is what I reach for most as an adhesive; the matte variety is my preference. I recommend soft gel for gluing all collage papers, and heavy gel for heavier items. Elmer's Glue-All is my PVA of choice, and I use Elmer's Wood Glue when I need a stronger bond. When I need glue for fabrics, my favorite is Sobo fabric glue. Masking tape is my favorite tape, but I use painter's tape when I tape over paint and need to remove it without taking the paint with it. Duct tape comes in so many colors now that I often use it inside my books.

Pens and Pencils

Out of all the pencils out there, I use a no. 2B and no. 6B most of the time. The lead in a 2B is harder and a bit lighter than a 6B, which is softer and good for shading. Any eraser will do for the projects, but my personal preference is a kneaded eraser. Another pencil I'm very fond of is a black waxy pencil called a Stabilo All pencil because it will mark on a variety of surfaces and is wonderful for shading. It comes in other colors as well, but I stick mainly to the black and brown ones. I use colored pencils with both acrylic and oil, and have a large collection of Prismacolor pencils that I am fond of, but my absolute favorites are my set of Lyra Color Giant pencils, that are made in Germany. Another chunky favorite is a Lyra Graphite crayon.

We'll use a charcoal pencil or a stick of charcoal for one of the projects, and we'll use both white and black gel pens frequently. (Make sure the ones you use work over acrylic paints.) My preferred brand is uni-ball. I use paint pens on fabric and paper, and my favorite brand is uni POSCA, the fine line type. This pen comes in a variety of colors.

Color

Acrylic
I use all types of acrylic paints. Craft paints are less pigmented and have a chalky look, and I use them when I want that effect. I like Golden Heavy Body Acrylics for blending flesh tones and use their Fluid Acrylics when I want a dilute paint-and-water wash. I use Golden Acrylic Flow Release, an additive, as a resist in one of the projects.

Oil and Pastels
Shiva Artist's Paintstiks Oil Colors are a handy and portable way to use oils in a creamy form. Once you remove the outer self-healing skin, you can color directly with it, as you would a crayon, or cut off a little to use and mix on your palette.

PanPastel painting pastels, a kind of chalk pastel, come in their own little containers and a large number of colors. Water-soluble oil pastels are waxy and act as a resist when used with acrylics. I'm not picky about brand—a cheaper student grade works for me here.

Gesso
I buy white gesso and clear gesso by the gallon, so you know I use it a lot. I use white gesso as a primer on most substrates as well as an alternative to Titanium White when I want a chalky, flat look. I use clear gesso over a painted layer when I'm going to add a layer of pastels, colored pencils or watercolor crayons because it gives the surface tack for the color to grab onto.

Watercolor
I frequently combine watercolor crayons with acrylic paints when I work, using them with both wet and dry paint. My favorite brand is Caran d'Ache Neocolor II Crayons.

Inks and Dyes
There are so many kinds of inks and I like them all. In these projects we'll be using walnut ink in brown and pigmented versions. I make my own walnut inks but there are several good brands available in art and craft stores. Sumi ink, a water-resistant ink, is made from vegetable soot. India inks come in a full range of highly pigmented colors which can be diluted with water for ink-wash paper. Dr. Ph. Martin's Bombay India Inks are my favorite brand. When I do rubber stamping with mixed media, I use StazOn ink pads, a transparent, solvent-based ink. For drawing directly on fabric and freezer paper transfers, I use Pentel Fabric Fun Pastel Dye Sticks.

Tools for Applying Paint

Try experimenting with a variety of acrylic brushes including a detail brush; my favorite is a round 00. I recommend a couple of small, cheap bristle brushes to use with oil sticks. Palette knives come in all shapes and sizes; I go for the small triangular ones for painting and a small putty knife is handy for applying joint com-

pound. When working with diluted paint and dye, we'll be using spray bottles (you can get small ones in the cosmetic section of discount department stores), eyedroppers, a toothbrush, skewers and sticks.

Cutting and Measuring Tools

We'll be using a self-healing mat, straightedge, and a ruler for several of the projects. A rotary cutter is handy for cutting fabric, but sewing shears will also work. A box cutter with several replacement blades and a craft knife are essential for cutting cardboard and foam core. I would feel lost without my box of razor blades because I frequently use them to scrape or burnish collage papers. Alternately, you could use a retired credit card or sturdy square of matboard. You'll need a pair of sharp scissors, an awl for poking holes in book-making projects, a drill (hand or power) for one project and a wire cutter.

More Tools

You'll need a needle-nose pliers, some large binder or bulldog clips, and a serrated knife or sharp tool that can cut through floral foam. For mixing up the papier mâché clay, you'll need a hand or bowl mixer. I use an old hair dryer to speed up drying time when I work.

We'll be using a sewing machine for several of the projects, although hand sewing is acceptable if you don't have one. A tapestry needle with a large eye works well for sewing with linen or embroidery threads. You'll also need an iron and ironing board.

Hardware Store Supplies

We're going to use all-purpose joint compound in several of the projects; it's ready-made and comes in a plastic pail. You can find it in the drywall section of hardware stores. You'll also need a medium-grit wet/dry sanding block and dust mask to block the fine drywall dust particles.

You can get linseed oil and turpentine here too. We'll use the linseed oil to aid in moving and blending oil sticks and the turpentine to clean the brushes.

You'll want a small ball of jute or hemp twine, and a small amount of annealed bailing wire. You'll find swivels in the fishing section; the range of hole sizes varies—the larger the number, the larger the hole. I use anything between 7 and 10. The last item you'll need here is called Nevr-Dull and is in the section with the floor/furniture cleaners and polish. If you don't find it at your hardware store, try the auto supply store; they also usually carry it.

Encaustic Supplies

For the wax projects, you will need a small melting pot to melt clear encaustic wax. A cheap 2" (5cm) wide chip (bristle) brush found in the paint department works well for spreading the hot wax. You'll need a scraping tool (mine looks like a half moon—one edge is straight—and I bought it at a ceramic supply store). An electric heat gun is used to fuse the wax; it looks similar to a hair dryer. I like to use the small sheets of Staedtler foil made for use with a hot foil pen. I don't use the pen with it though; I just buy packs of the foil refills.

Fabrics and Threads

You'll need some pieces of smooth weave cotton or silk fabric for the dye stick transfers, a variety of fabric scraps, and bits of lace and trim. We'll be using crisp organza, cheesecloth, felted wool sweaters and stuffing material. You can use extra bits of the sweater fabric for stuffing or cotton or polyester fiberfill sold for that purpose in fabric stores. You'll need a small piece of stiff interfacing or webbing and a variety of embroidery threads. For the closure on one of the books, you'll need a piece of new or recycled leather cord.

Collage

This is a broad category and includes everything paper and all the other three-dimensional bits I might add to a piece. You will need a few photo printouts of faces, vintage books for text and spines, magazines with lots of colorful images and a variety of miscellaneous printed papers. Wallpaper is one of my favorite items, and you can find unique papers in scrapbooking and art stores as well. For three-dimensional elements, consider natural items such as dried flower petals, shells, twigs and moss, as well as found objects, buttons, beads, small mirrors and any other personal ephemera.

Other Papers

We'll be using carbon paper in one of the projects, and you can find boxes of old typing paper at garage sales or thrift stores, which works great. If you don't have that, you can purchase graphite paper from the art supply store. You'll also need some tracing paper or, the alternative, deli wrap, which you can find in your grocery store. You'll need some cheap paper, like newsprint, some large envelopes (or I describe how to make your own in the specific project), parchment paper and waxed paper. Also, a small amount of any kind of tissue paper—recycled is fine.

Miscellaneous Odds and Ends

This is the "everything else" that didn't fit into one of the previous categories. You'll need a piece of floral "dry foam" found in the floral department in craft stores. They also carry a variety of rubber stamps, which can be fun to include in projects, especially the various sizes of alphabet stamps. Punchinella, also called "sequin waste," can be purchased in many fabrics stores, locally or online. You'll probably have plastic wrap, salt and flour in your kitchen, and rubbing alcohol in your bathroom. In one project, you'll need a wine cork; in another, a pop top from a can. We'll be using a small sheet of mica to cover a niche in one of our books, and a vintage hanger or other suitable object to use as a base for our wall hanging. Last of all, you'll need items to use for texture, such as plastic doilies or tablecloths, embossed trivets and bubble wrap.

From Poetry to Painting

The fifteen projects that follow each come with a specific writing exercise and poetry prompt, a supply list and individual photographs with directions that illustrate and walk you through the project, step-by-step. I encourage you to do the writing exercise before you begin a project. The writing part generates imagery and feeling that you may want to bring into the project with you. Even when the poetry writing is unrelated to the project itself, think of the writing as a valuable warm-up exercise, bringing expanded self-awareness to your art-making process.

This book pairs poetry writing exercises with mixed-media projects in the hope that the combination of the two will expand and deepen your creative process. Sometimes paintings inspire poems; other times you might write a poem and afterwards feel the imagery wanting to come alive in your art. Like a solid marriage, it seems each brings out the best in the other.

I've learned to expect the unexpected when I make art. There are times when I sit down to paint, not knowing where the piece will go but following my intuition as it guides me along, one step at a time. Maybe suddenly, I spot a word sticking out from my box filled with collage papers, and that particular word yells for my attention. If I listen and follow that word, a hidden door will undoubtedly appear, with a keyhole the exact size of that word. In an excited state, I'll probably drop my brush and start leafing through old poetry books in search of other words that also fit, words that, when put together in just the right combination, will open that door, allowing me to enter both my poem and painting more deeply.

It's not a science, and you can't force that door to appear or to open; if it does, it's grace, plain and simple. All you can do is take action with as much awareness as you can muster. When you're painting, really show up to paint. When you are doing the writing exercises, be as present as you can and write from the heart. All we

> **A work of art is one through which the consciousness of the artist is able to give its emotions to anyone who is prepared to receive them.**
>
> *— Muriel Rukeyser*

can do is make the moves, and then, as a teacher metaphorically illustrated, "You just stand in the middle of the road and wait for the bus of Grace to mow you down." But you do have to make the moves first.

The poetry prompts are simple and meant to be fun. You'll be playing with words, putting some down on the page, and shaking a few images around before you roll up your sleeves to do the messy parts (at least if you're a messy artist like me). Nothing needs to make sense or look pretty; the destination in this journey is exploring the ever-changing nature of "what is" through words, paper and paint

Even when I can't explain what my poem, collage or painting means, I can still recognize a part of myself there, an essence of my consciousness, that permeates and lingers around it. Whether we are writing poems or creating mixed-media art, when we hold the intention to stay present in the unfolding moment, the door does open, and we find ourselves free to wander our inner landscape. It's safe to be curious in that place, to explore and navigate feelings, excavate personal history, probe judgements and follow dreams as they arise. We are transported back to ourselves in this space and allowed to experience how our every step joins with the Mystery—to manifest our unique presence in each brushstroke, in every line of poetry we write.

i remember
content
i am a bird

Poetic Projects

On your mark, get set, GO! . . . At your own pace that is. There is such diversity in these projects that you could linger with one project or technique for quite some time, learning, growing and changing with it. That's exactly what I hope you'll do—find something in here that really intrigues you, maybe even stretches you out of your comfort zone, and dive in!

You hear people talk about someone's style—maybe you know what yours is, maybe you have yet to discover it. As for me, my artistic spirit needs a lot of room to move about and can feel confined if I'm told to create in a certain way. I like to sit with a project and then change it up so it feels right for me. I hope you will do the same with these projects; try one on, see how it fits, then make the alterations and modifications you need to so it feels like it's yours.

Maybe you are one who works best following the directions to the letter the first time through, or second or third time until you feel really comfortable, and that's fine too. Whether you decide to make the projects just like I've shown or veer off in a different direction, I hope you remember to experience creative joy in the present moment, whether you're tearing a piece of paper for collage, spreading glue with your finger, cutting cardboard with a craft knife or feeling the wooden brush against your fingers. The present moment is where the juice is!

Every Face Tells a Story

Painted Face Value Study

Every face is defined by its shape and skin tone, the size, color and sparkle of the eyes; the texture of hair or absence of it; the changing shape of the mouth; the rose in the cheek; or untold stories etched in silent wrinkles. The face is also a vehicle for expressing emotion. We need not utter a sound; the eyes alone are a window to the soul.

In this project you will be experimenting with contrast using both collage and paint to create a face. The idea is NOT to reproduce the face you started with, but to use this face as a value guide to inspire you to paint a unique face of your own. You will build light and shadow with various colors; however, the color itself isn't as important as the value. An easy way to determine value is to squint at something.

When you find yourself "in the flow" as you create, follow the lead of your intuition: experiment, deviate, take a chance. If you get lost, you can always come back to the original print and come back into your painting with line and contrast.

> **The eye with which I see God is the same eye with which God sees me.**
>
> —*Meister Eckhart*

Supplies to Gather

- collage paper scraps
- scissors
- black-and-white photocopy of a face, such as one from a magazine
- 140-lb. (300gsm) watercolor paper
- carbon paper
- tape
- dull no. 2 pencil
- soft gel medium
- razor blade
- Stabilo pencil
- acrylic paints, assorted colors, including "face colors": Phthalo Blue, Naphthol Red Light, Hansa Yellow Medium, Titanium White, Quinacridone Crimson, Quinacridone Nickel Azo Gold, Payne's Gray and black
- palette paper
- paintbrushes
- water container (to rinse brushes)
- soft cloth
- rubbing alcohol
- white gel pen
- white gesso
- tracing paper or deli wrap

Expression Direction

Look into a mirror, staring into your own eyes, examining your face, for at least two minutes. Make mental notes of thoughts and emotions that arise. Afterwards, write down a column of words or short phrases to represent observations about your experience. Here are a few questions to get you started: Describe the eyes that looked back at you. What is the mouth saying, even when it is closed? Does the reflection seem happy, sad, scared, peaceful or . . . ? What secrets does the mirror reveal about you that you find difficult to see?

Circle ten of these words and phrases and compose a "self-portrait" poem with them. Make sure to write the date on it. Repeat this exercise once a day for a week and notice the variations you discover, if there are any.

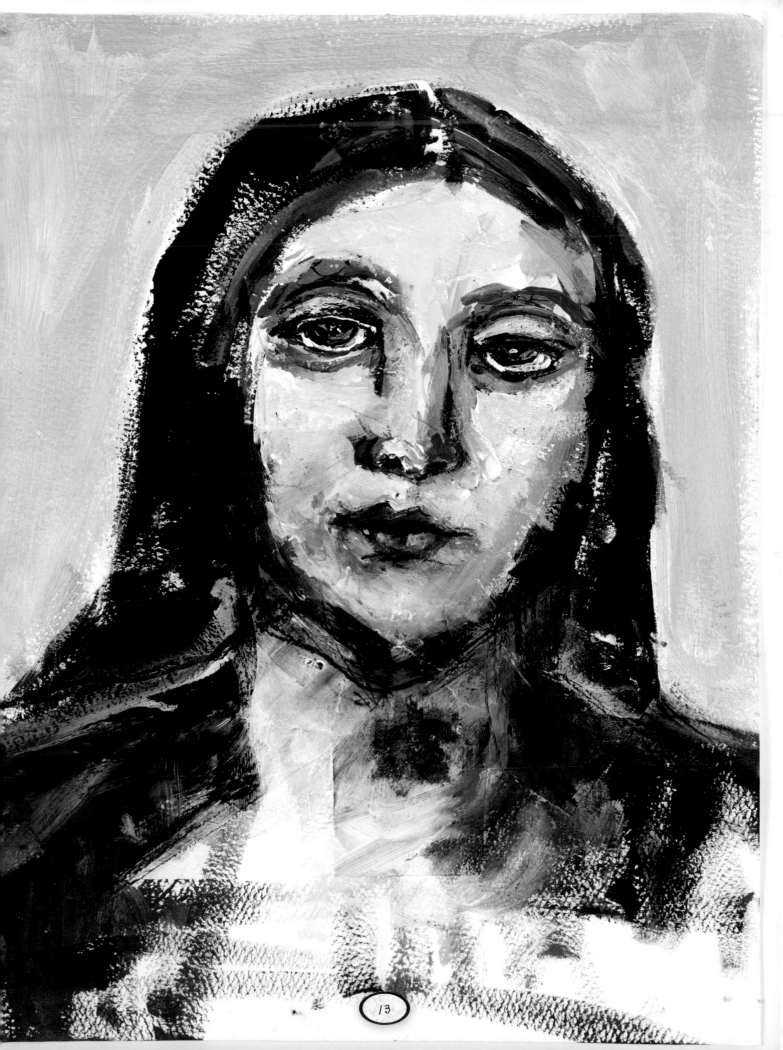

13

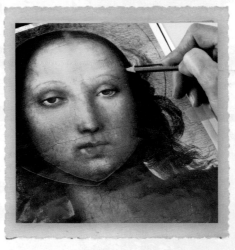

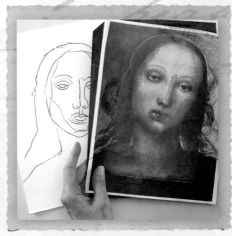

1. Gather small pieces of various collage papers and separate them out in piles of light, medium and dark. Cutting up magazine papers works well for this.

2. Find a face you like with defined contrast, mainly light and dark areas with a minimum of grays. Use a photo-editing program to convert your picture to black and white with high contrast. Print out a copy about the same size as your paper. Tape it to a piece of watercolor paper with a piece of carbon paper sandwiched between it and the watercolor paper. Use a dull pencil to trace over primary lines that separate the light and dark areas. You're not trying to reproduce every line, just the general form.

3. Remove the carbon paper and face image.

4. Using gel medium, begin gluing down pieces of paper to the face, using the original face print as a guide for the placement of the light, medium and dark papers. Use a razor blade over the paper to work out any air bubbles trapped in the glue. It's fine to let the paper pieces overlap lines and into other areas. You can use a Stabilo or graphite pencil to retrace lines when necessary.

5. Set up your palette with your paints. I recommend using two blues: Payne's Gray and Phthalo Blue; two reds: Quinacridone Crimson and Naphthol Red Light; two yellows: Quinacridone Nickel Azo Gold and Hansa Yellow Medium; Titanium White; and a black.

Homemade Palette Pad

For a cheap and easy homemade palette pad, cut a dozen pieces of freezer paper and, with the shiny side up, staple them together. Tape the stack to a slightly larger cardboard base using duct tape. Use a piece of removable duct tape at the bottom of the page to keep the paper from curling.

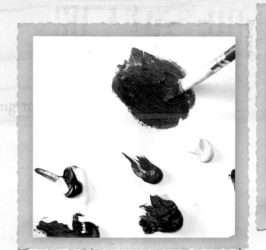
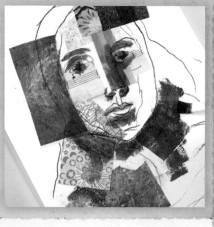
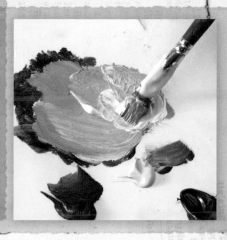

6. Pick up a small amount of each red and yellow on your brush and mix them together. Then add a tiny bit of the blue. This combination gives you a dark value flesh tone that can be tweaked warmer or cooler by adding a touch more of the yellow, red or blue.

7. Paint the dark value flesh tone on areas of the painting that you see as dark.

8. After the darks are laid down, add a little white to the mix to create a medium flesh tone.

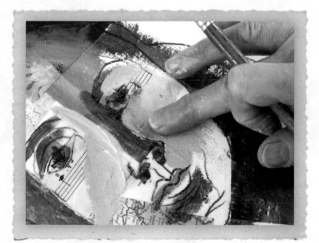
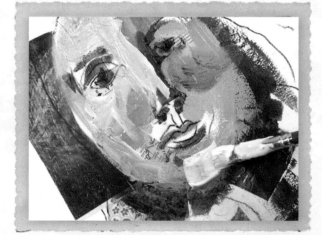

9. Paint this medium tone onto the face in what would be the gray areas of your painting. This is not precision paint-by-number painting. It helps to have a bit of a slap-dash attitude when putting down paint.

10. To add rosy tones to the face, mix a tiny bit of red to the dark flesh tone and apply it to the cheeks and lips. Pick up additional white, mix it into the flesh tone and start adding some light areas.

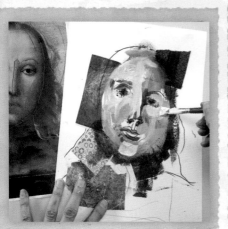

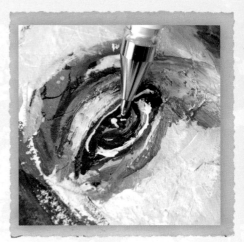

11. Continue adding whitened highlights to the areas that need it, using the original art as a guide.

12. To reveal elements of collage paper that may get buried under paint, use the tip of a soft cloth soaked in rubbing alcohol and rub the area gently to lift off some of the paint.

13. For the finishing line-work details, use a Stabilo pencil to detail the pupils, lids and other areas of the eyes. A white gel pen works well to add a highlight to the pupils.

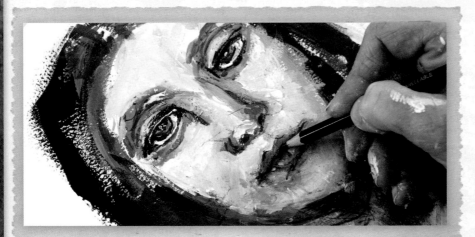

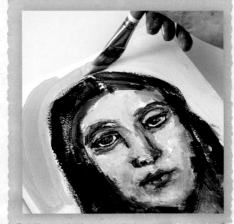

14. Detail the nose and lips in this way as well. Gently smear a line with your finger if it appears too bold.

15. Continue working the face, head and just hints of the torso, keeping in mind that it's not necessary to add in every last detail.

For the background behind the head, paint the area with a layer of white gesso and then add the color(s) of your choice. If you're unsure of what color to use, identify a prominent color in the painting and select its complement (the color opposite it on the color wheel) to make your painting "pop."

Beneath the Layers

If you're unsure of a background color, trace the silhouette of the figure onto tracing paper or deli wrap, and then use it as a template on watercolor paper. Apply different colors to the watercolor paper and hold it up to the painting to try the colors out.

She Didn't Know Until She Got There That They Had Been Dreaming of Her, Too.

This piece was born of my imagination. I didn't have any idea what it would be before I started; the story evolved one image at a time.

Poetic Purpose

Make a dozen mixed-media postcards from recycled materials. You could do small versions of simple faces using this project technique. On the back of the card, write a short poem or an inspiring quote. Keep them in your pocket or purse and give them to strangers you cross paths with during the day. Be aware of your thought process as you decide who you choose to be the recipient and why, or is it random? Make notes of your observations, both internal—regarding your thoughts and feelings—and external—details about the place, time, how the recipient received your gift, etc. Keep these notes to use as inspiration for future poems and paintings.

Memories of a Dream
Underpainting and Color Mixing with Basic Colors

Dreams inhabit the secret spaces in and around us. Have you had the experience of waking up to a dream so full of life, color and mystery that all you want to do is go back into it and explore, to more fully understand the contours of the landscape and meanings behind the mystery?

A dream has its own undertone, a flavor that permeates the characters and every aspect of that world. It may be adventurous, frightening, magical or soulful—only you, the dreamer, know. The undertone, although easy to identify, can be hard to describe—a cross between sticky syrup and pixie dust. It is in this place where all the dreamtime characters make their home, where they hide their secrets and tell their stories in foreign tongues to you alone.

In this project we write to help us remember, to bring images to the surface, to feel the dream undertone. Once found, we take a giant leap back into it, with intuition and intention serving as our guides; paper and paint as our mirror.

> **Dreams are illustrations from the book your soul is writing about you.**
>
> —*Marsha Norman*

Supplies to Gather

- old album cover
- waxed paper
- painter's tape
- white gesso
- acrylic paints, assorted colors: Titanium White, Naphthol Red, Cobalt Blue, Van Dyke Brown, Hansa Yellow Medium
- palette paper
- paintbrushes
- water container
- clear gesso
- hair dryer
- Stabilo or soft lead pencil
- baby wipes or wet cloth
- no. 2 pencil
- sharp skewer

Expression Direction

Write about a dream you had recently, recording as much detail as you can remember. After you're done writing, use a highlighter to color each word or phrase that feels particularly significant. On a fresh sheet of paper, transfer each highlighted word or phrase leaving space after each to write down the symbology or personal significance. Some things to consider: Does it have personal historical meaning? Is it a play on words or synonym?

Does it elicit a particular emotion? Is there a color or texture you associate with it? Write as much as you can; one thought will lead to another. Go back to the beginning and circle words that strike an emotional connection.

Now write a poem using the words you have circled. Feel free to add to and rearrange the words as needed.

Using your poem as a guide, draw and then paint your dreamscape. Pick a paint palette that reflects the mood of your dream world. The color you choose for the underpainting will represent the undertone of the dream. Using pencil and paint, recreate this world. Notice any feelings or thoughts that come up while you paint and, when you're finished, record them in your journal. Glue or tape your poem to the back of your painting.

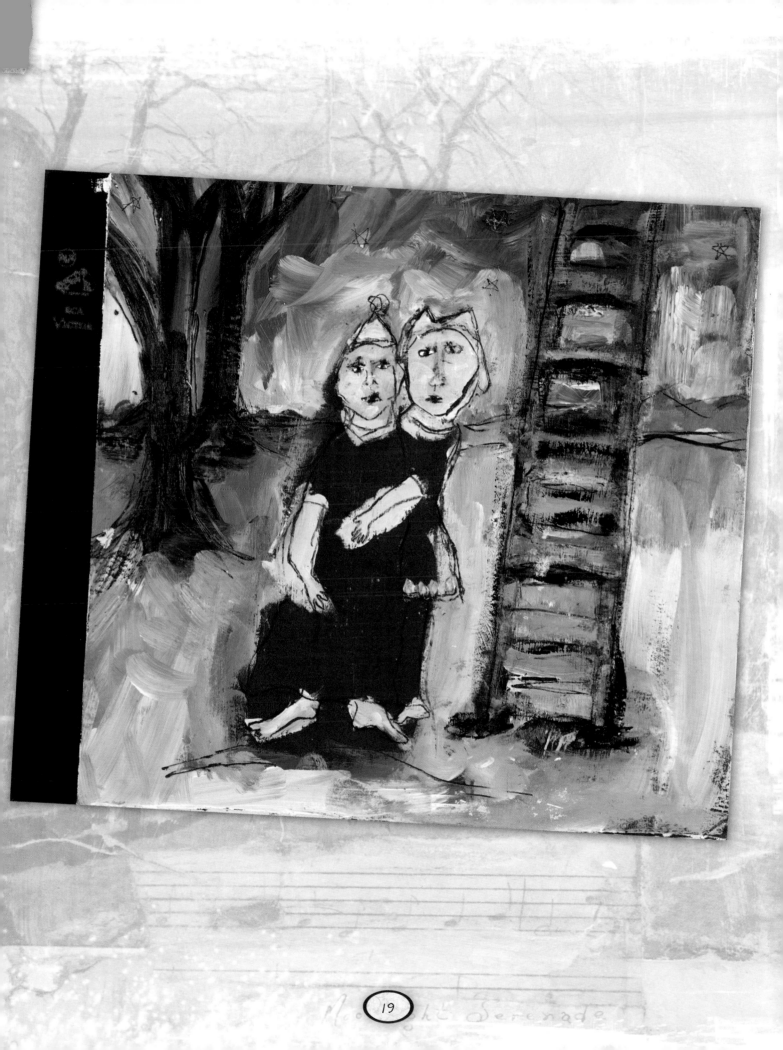

Moonlight Serenade

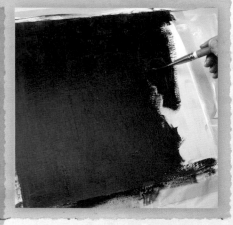

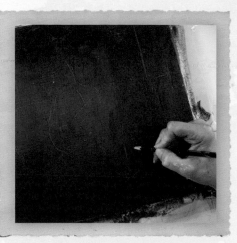

1. Tape your album cover to waxed paper with painter's tape to protect the back from paint. Apply white gesso over the entire front surface.

2. Paint the entire surface with an undercoat of paint that reflects your dream undertone; here I used red.

3. When it is dry, apply a layer of clear gesso over the entire surface and let that dry completely. You can speed up drying time by using a hair dryer. Sketch out your composition using a Stabilo or any soft lead pencil. Use a wet cloth or baby wipe to rub off and redo your penciled areas.

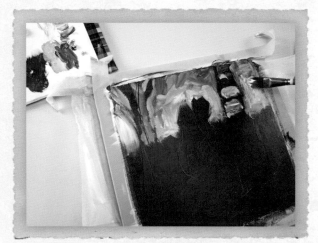

4. Begin painting in the sky portion using strokes of blue mixed with white.

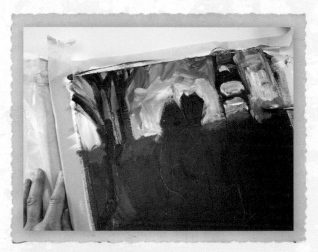

5. Now add in the trees using Van Dyke Brown and a bit of yellow.

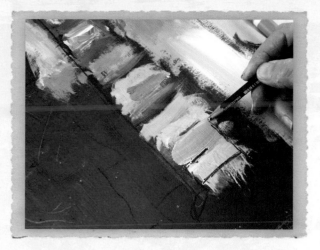

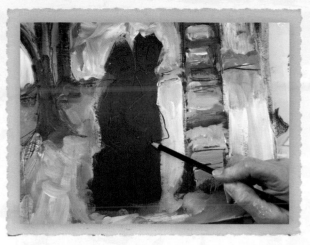

6. Next move on to the ladder. Mix a little yellow with the sky colors to create green and paint that between the ladder rungs. Let some of the red underpainting show and touch up with more red in green areas where needed. Continue adding shades of green below the horizon line.

7. Sometimes it's helpful to go back and add details back in with the pencil.

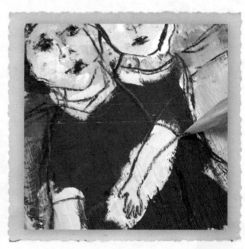

8. Continue filling in all of the background using a variety of colors. Mix a little red, white and yellow together on your palette to create a flesh tone and add that to the faces, arms and legs. Pencil in defining details using a no. 2 pencil.

Use a skewer or other sharp tool to scratch out additional lines where you'd like the red underpainting visible.

Poetic Purpose

Sew a small dream pillow filled with dried chamomile, mint and lavender for someone having trouble falling asleep. Include a card with instructions to tuck this small pillow inside their own pillow for a relaxing and aromatic treat.

When She Grew Up, She Wanted to Be a Poem

Collaged Background and Combining Painting with Words

I had no beginning or end in mind when I started this piece, just a burning desire to play with paint and paper and see where it would all take me. The key word here is PLAY. I love the element of surprise inherently built into the process of playing. It is the compelling force that keeps bringing me back, expectant and continually surprised.

With vast freedom and few boundaries, you may find yourself feeling a tinge of confusion or even outright terror, wondering where in the world to start. The Expression Direction for this project is designed to generate vivid imagery in your mind's eye that will hopefully be a rich source of inspiration for your painting.

I also find doing a first layer of collage is a reliable way to ground myself, creating a solid layer of texture to jump off from, and is far less intimidating than a direct plunge onto the blank page.

Sometimes when my mind is relaxed and my fingertips covered in glue, an image comes to mind, or a certain collage paper will call to me when I'm digging in my pile, and just like that, I have an idea, a direction to follow. No matter what you do or how long it takes, one step will always lead you to the next; I find that very reassuring.

> **And the day came when the risk to remain tight in a bud was more painful than the risk it took to blossom.**
>
> —*Anaïs Nin*

Supplies to Gather

- watercolor paper
- collage paper pieces
- soft gel medium
- razor blade
- white gesso
- baby wipes, paint cloth or paper towels
- rubbing alcohol (optional)
- bubble wrap
- punchinella
- acrylic paints, assorted colors: Titanium White, black, Phthalo Blue, Quinacridone Nickel Azo Gold, Iridescent Bright Gold, Hansa Yellow, Naphthol Red, Van Dyke Brown
- palette paper
- paintbrushes
- water container
- no. 2 pencil
- Stabilo pencil
- scissors
- white paint pen
- watercolor crayons

Expression Direction

If you could be a poem, what kind of poem would you be? A love poem, inspirational, haiku, ballad, spiritual, silly, rhyming, wild, strong, magnificent, natural?

On a sheet of blank paper, randomly glue down words cut from a discarded poetry book—words that belong in your world. Paint a poem with words, describing a day in your world, using some of the words from your list. You might describe what you see, the color of the trees, the season of the year, the house you live in, etc.

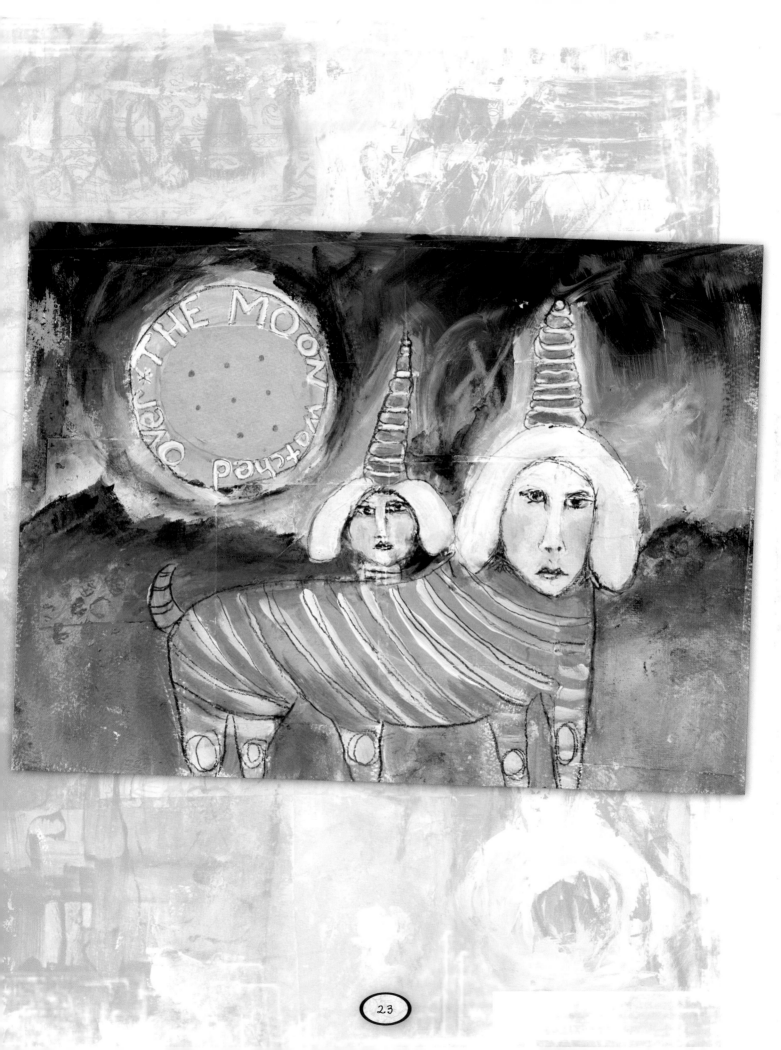

THE MOON watched over

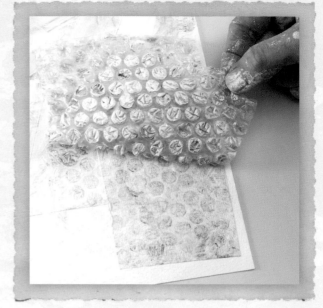

1. Cover your watercolor paper with random pieces of collage paper, gluing them down with gel medium and smoothing the bubbles out of each piece using a razor blade.

2. Brush white gesso over most of the surface and rub out some of the areas using a baby wipe. If you can't rub out enough in some areas with the wipe, use a paper towel and rubbing alcohol. To create some texture, while the gesso is wet, press bubble wrap into an area of it and lift it off.

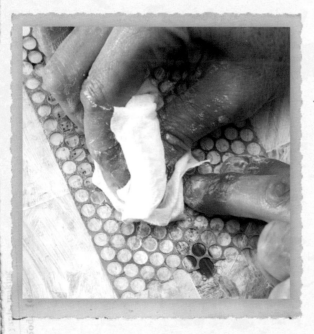

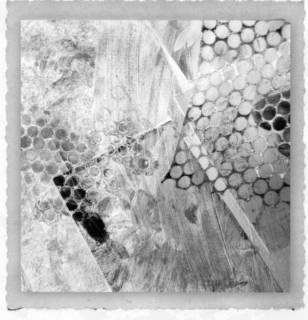

3. Also rub over a piece of punchinella.

4. Lift it off as well.

5. Continue doing both of these techniques in a few places. You can also press the bubble wrap into brown paint and use it like a stamp in some areas, such as where you will later create a mountain range. When your paint is dry, use a pencil to sketch in your composition.

6. Paint in the sky area using strokes of blue and blue combined with white.

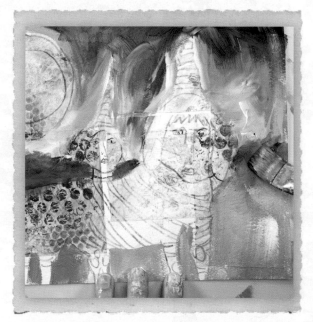

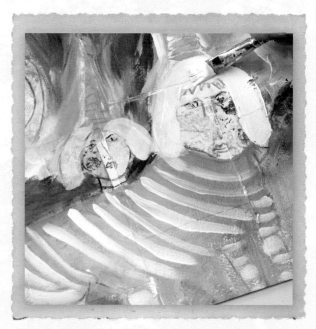

7. Paint in green areas below the horizon, using the darkest green where it meets the sky and lighter green in the foreground.

8. Paint in the creatures and their faces and their stripes.

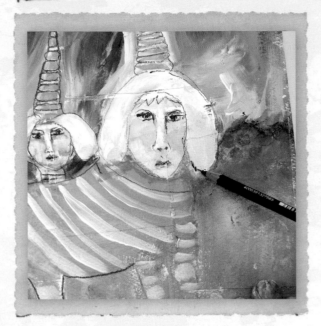

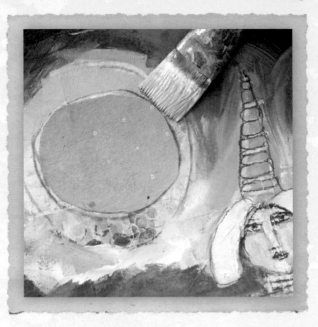

9. Add details with a Stabilo pencil.

10. Cut out a piece of yellow collage paper and glue it to the center of the sun. Blend into it a lighter mix of yellow paint around the perimeter.

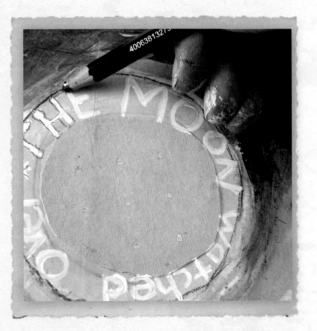

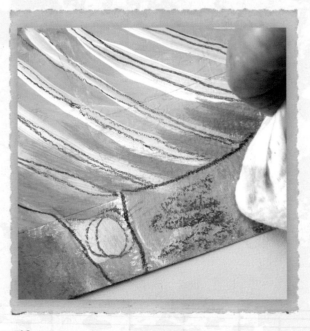

11. Use a white paint pen to add writing to the inside edge of the sun. Highlight letters with a paintbrush and white paint to make them stand out. Outline the edges with a Stabilo pencil.

12. Some areas of green and blue can be enhanced with a watercolor crayon. Rub a crayon onto the paper, and then work it in a bit with a baby wipe.

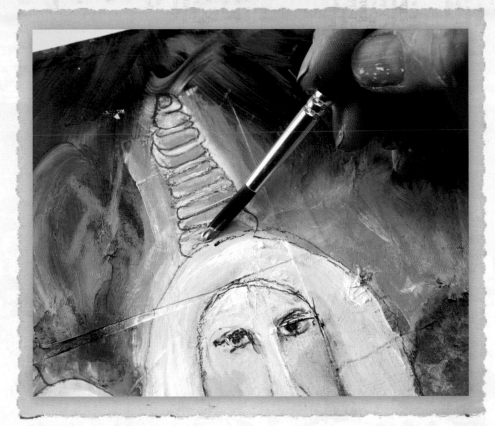

13. Add a royal treatment to the horns with some stripes of gold paint.

Poetic Purpose

Make a reduced print of your artwork for the front of a handmade card. Include a copy of the poem you wrote inside. Send this to a new friend or to someone you would like to get to know better. You are giving someone a gift of yourself.

Personal Symbology Wall Hanging

Crayon Rubbings in Collage and Nondominant Hand Drawing

In this project I'm combining several of my favorite techniques with objects that hang and swing, painting and mark making with personal symbols, beads, buttons and little pieces of junk, fabric, wood, shells and small, odd items. You'll see photos of two versions, but I'm sure if you make one, you'll have ideas for numerous future variations.

You can use any paper you have around for the substrate; you don't need to go out and buy anything specific. Recycled paper bags, catalog pages, junk mail, Tyvek or paper-packing envelopes and wallpaper are all good options.

You'll need to gather a variety of images for the first collage step. I find the images are most meaningful if they contain several of your personal symbols. If you can't find many symbolic pictures to cut out and use, draw and paint them or write or stamp them as words. If you're not sure what your personal symbols are, think of objects that you are attracted to and use repeatedly in your artwork, or possibly images that come to you again and again in your dreams.

Some of my own personal symbols include ladders, circles, clouds, sheep, third eye, hands, hearts, animals, trees, boats, water, throat chakra, blue, create, disappear, doors, windows, nature, rabbits, levels, stairs, quirky, hats, masks, forest.

> ## It don't mean a thing if it ain't got that swing.
> —*Duke Ellington and Irving Mills*

Supplies to Gather

- soft gel medium
- collage papers
- paper for substrate
- textured objects for rubbings
- deli wrap or tracing paper
- wax crayons or oil pastels
- acrylic paints, assorted colors, including black
- palette paper
- paintbrushes
- water container
- Stabilo pencil
- craft knife
- cutting mat
- foam core
- scissors
- baby wipes

- metallic copper paint
- ½ yard (46cm) of crisp cotton organza/organdy
- heavy gel medium
- straight pins
- 19-gauge annealed steel wire
- wire cutters
- needle-nose pliers
- size 7 bearing swivels (found in sporting goods store in fishing section), 24–30
- wood glue
- jump rings
- miscellaneous beads and ephemera
- vintage clothes hanger

Expression Direction

Write a list of your personal symbols. Next to each symbol, write what it represents to you. If you aren't sure, make a guess. Write a poem that includes a symbol from your list in every line.

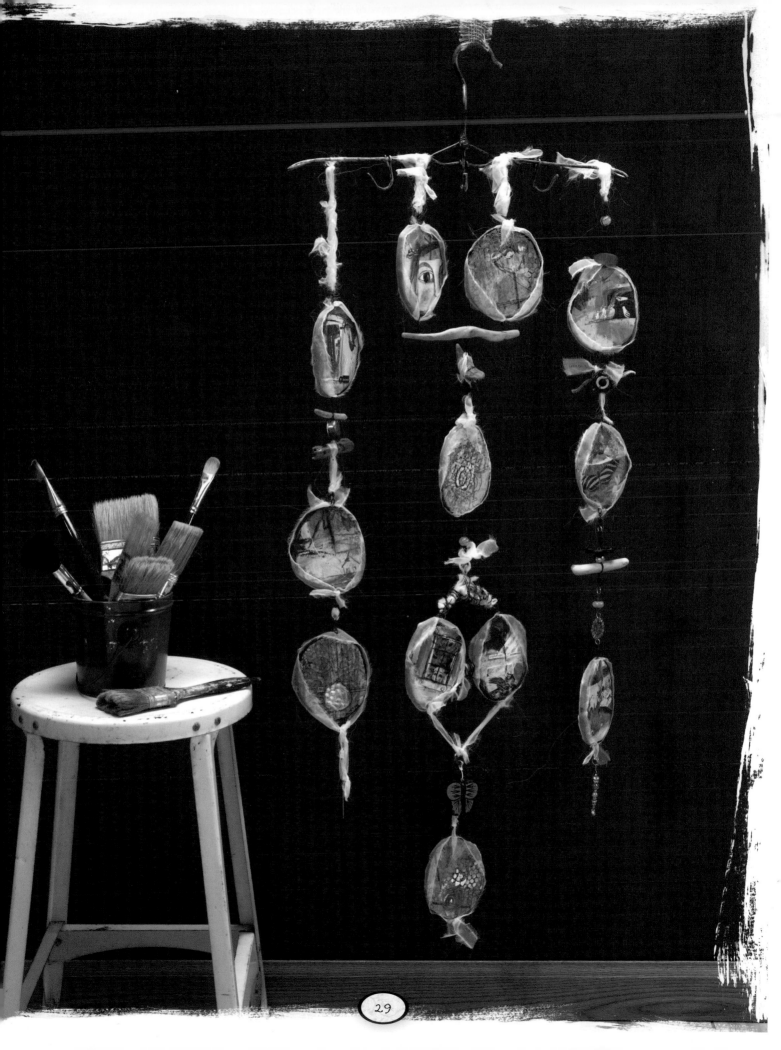

1. Using soft gel medium, glue your collage images down on a total of four 12" x 16" (30cm x 41cm) pieces of paper of your choice or a combination of papers of a comparable surface area.

2. Gather up some surfaces you like with interesting textures.

3. Lay a piece of deli wrap or tracing paper over a surface and rub over the top with a wax crayon or oil pastel.

4. Here are some finished examples.

5. Glue some of the rubbings over parts of your collage papers using soft gel medium.

6. Paint around your collage images using a limited color palette. Hold the paintbrush with your nondominant hand to tap into the "child" part of you. Use a pencil or sharp object to write and draw into the areas of wet paint.

7. Try using your finger as a paintbrush.

8. Using a craft knife, cut 12 ovals out of foam core that measure approximately 4½" x 3" (11cm x 8cm). Designate one side as the front and one as the back. (You may want to cut out a stencil in the shape of your oval to help you see shapes in the large paper more clearly. Move the stencil over various areas of the paper until you find the spot you like.) With the appropriate side up, trace around a portion of the collaged and painted paper. Cut it out, then glue that piece to the top of the foam core with soft gel medium.

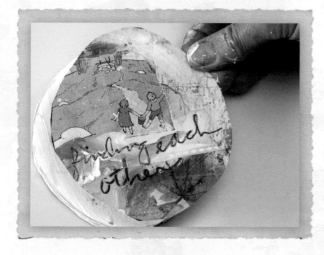

9. Turn the foam core piece over and trace a second area that will go on the back side. Cut out and glue that one on the back side.

10. Repeat for 11 move ovals. Paint black paint around the sides of each foam core piece. Use a baby wipe to work the paint into the foam core and smear it over the surface edges a bit.

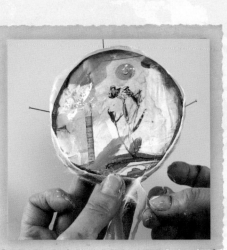

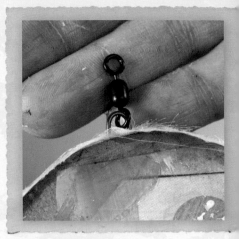

11. Add metallic copper paint to the surface edges of the front and back pieces, working the paint into the black edges.

12. Tear organza into strips that are about ½" (13mm) wide. Dab a speck of heavy gel medium at the 12, 3, 6, and 9 spots (imagine a clock) and use straight pins to hold the organza to the foam at those spots. Leave a 3" (8cm) tail at the bottom.

13. Repeat for the remaining ovals. To connect the ovals and assemble the hanging, begin by cutting 32 pieces of 1½" (4cm) wire. Bend these in half with your pliers to create staples. Thread a staple through a swivel and then push it into the top of the oval, through the organza, making a hole in the foam. Pull it back out, put a little heavy gel medium into the hole and press the staple and swivel back into the hole. Once the gel medium has dried, put a drop of wood glue on each of the wire foam core connections and let it dry thoroughly, at least 24 hours.

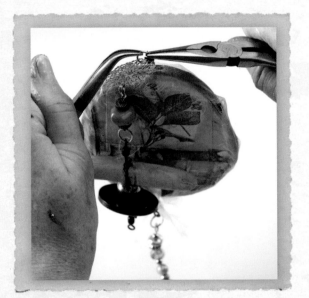

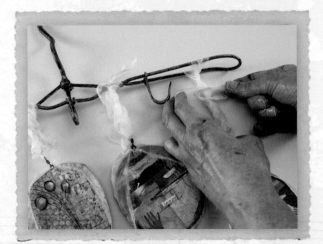

14. Repeat at the bottom and do the same on the remaining ovals. Lay all your discs out in front of you and decide how many rows you want, how long you want the rows, and where the individual discs should go. Line them up leaving appropriate spacing both vertically and horizontally to achieve balance. To connect the ovals together for hanging, secure any beads, charms or other elements to either jump rings or wire wraps and then connect them at the swivels.

15. Make the final attachment to the base (a vintage clothes hanger works great) with fabric, string or wire. Once all the strands are attached, add any final embellishments to the base if you like. Hang it up and enjoy!

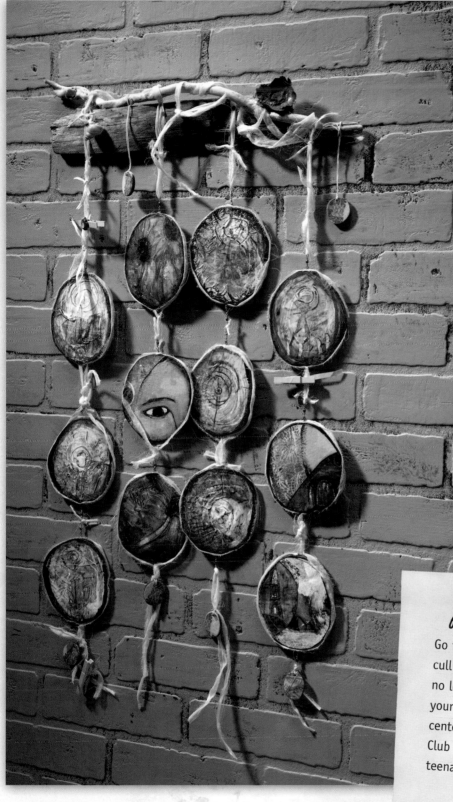

Hanging Variation

I used two pieces of found driftwood nailed together for the base of this piece. The larger, flat piece fits flush against a wall, making a nice solid support for a wall hanging. You could easily convert it into a mobile to hang from the ceiling by attaching a large swivel to the top of the wood base, right at the middle, and loop a cord through at the top.

Poetic Purpose

Go through your personal library and cull out arts-and-crafts books that you no longer need or use. Donate them to your local high school library, community center, local public library, Boys and Girls Club or other charity that works with teenagers who could benefit from them.

Windows of Change
Carving Cardboard and Picture Framing

Cardboard continues to be one of my favorite art materials. The biggest reasons I love cardboard: it's ecological (it feels so good to recycle), it's free and the possibilities for creating with it are virtually endless.

Before you begin, I suggest gathering several different pieces of cardboard. Play around with each a bit; use your craft knife on them to discover their unique characteristics. When you pull off the top paper layer, it's clear they aren't all alike. Some cardboard has more corrugation, some has stronger glue and sturdier paper, others have almost a crumbly consistency. An optimal cardboard for this project is strong and firm with defined corrugation.

To design the decorative scrollwork, fold a piece of tracing paper in half, position the fold at the center mark and freehand draw half the design. Turn the paper over and trace the other half to get a symmetrical pattern. If you prefer not to create your own pattern, numerous stencils are available in the painting and craft departments, as well as copyright-free designs through Dover books.

When deciding your color palette (if you use one other than the one shown), consider the style and colors of the paintings you will display. One of the added benefits of this frame is that you can change out your painting as often as you wish. If you'd like a more versatile frame that can go with a variety of color schemes and styles, consider using neutral colors and lighter accents.

> **If you don't like something change it. If you can't change it, change your attitude.**
>
> —*Maya Angelou*

Supplies to Gather

- 8" x 10" (20cm x 25cm) matboard
- pencil
- cutting mat
- craft knife
- 8" x 10" (20cm x 25cm) piece of cardboard
- sanding block
- tracing paper
- scissors
- heavy gel medium
- white gesso
- masking tape
- joint compound
- palette knife
- plastic doily
- face mask
- acrylic paints, assorted colors, including: Titanium White, Payne's Gray, Sky Blue, Classic Teal, Modern Red,
- Altered Orange (Claudine Hellmuth Studio)
- palette paper
- paintbrushes
- water container
- baby wipes and rag
- metallic copper paint
- text scraps
- 3 pearl buttons (2 small, 1 large)
- 6½" x 8½" (17cm x 22cm) matboard for back and strips
- pop top from a beverage can
- watercolor paper
- magazine face
- Nevr-Dull wadding polish
- clear gesso
- watercolor crayons: teal, white, flesh, pink, Napththol red light, Hansa yellow medium

Expression Direction

Take a few pages out of a discarded novel. Cut the pages into four or five columns and tape them together in a different order. Circle interesting phrases and then cut them out or rewrite them. Arrange them into a new and original poem.

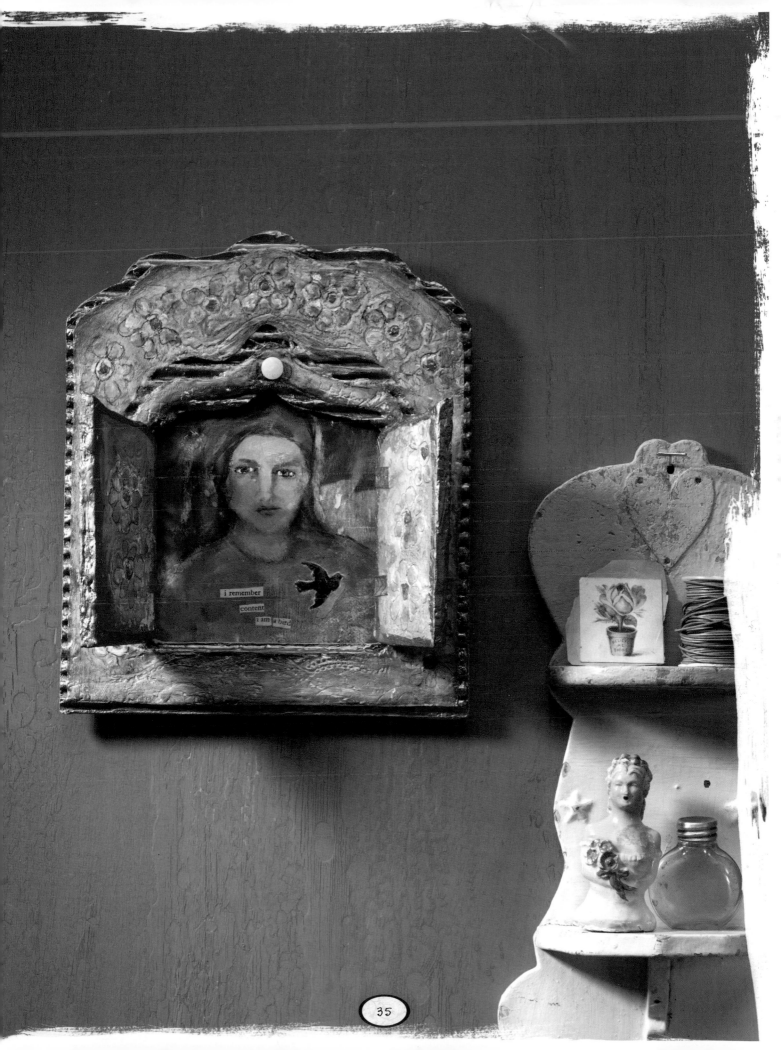

1. Draw a frame shape onto the 8" x 10" (20cm x 25cm) piece of matboard and, working on a cutting mat, cut the shape out using a craft or utility knife. Use this as a template to trace the frame onto a piece of corrugated cardboard.

2. Working on a cutting mat, cut the frame out of the cardboard.

3. Use a sanding block to sand the rough edges of the cardboard.

4. To create a decorative scrollwork for above the door, start by folding a piece of tracing paper in half and draw the element from the fold out. Cut out with scissors.

5. To create the doors, cut both the matboard and cardboard fallouts from the windows in half vertically.

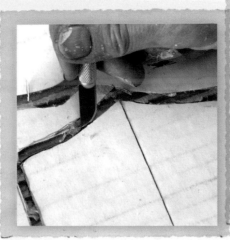

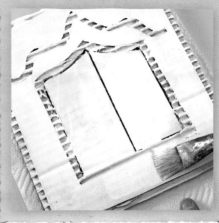

6. Using heavy gel medium, glue the cardboard frame to the matboard frame and the cardboard doors to the matboard doors. Use a pencil to trace your scrollwork onto the cardboard above the door, and also draw lines around the perimeter of the frame and the perimeter of the door leaving ¼" (6mm) margins. Use a craft knife to cut along all the lines.

7. Peel the layer of paper off the cardboard, revealing the corrugation beneath. Do this for all of the margins and the scrollwork.

8. Apply white gesso over the entire front of the frame and over the doors.

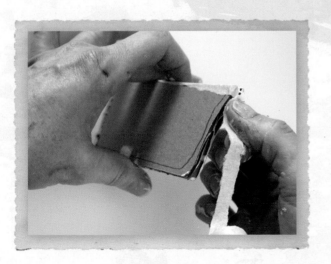

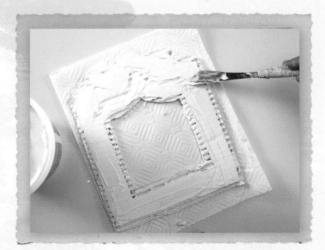

9. Apply masking tape over the edges of the doors.

10. Apply joint compound with a palette knife over the entire frame front and edges, and along the sides of the doors. You don't want a thick layer that will obscure the corrugation, just enough to cover the gesso.

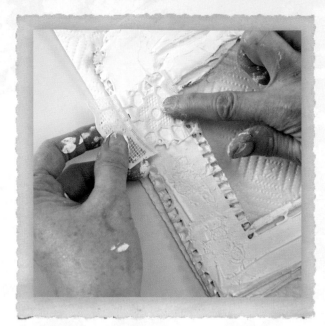

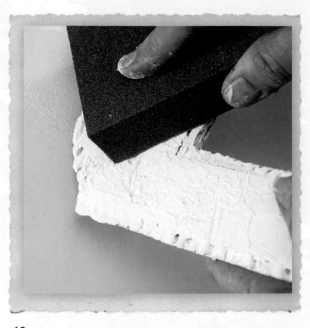

11. While the compound is still wet, press a section of plastic doily or other stencil into the plaster and remove. Repeat in several random places.

12. When the compound is dry, sand the surface using a sanding block. Sand over the entire surface of the frame and the doors. *Note: Wear a mask to do this because plaster contains gypsum, and you don't want to breathe in the dust.*

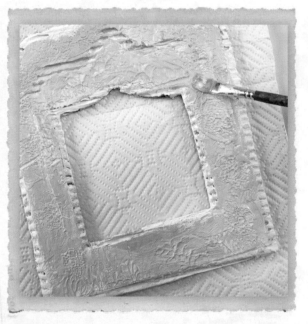

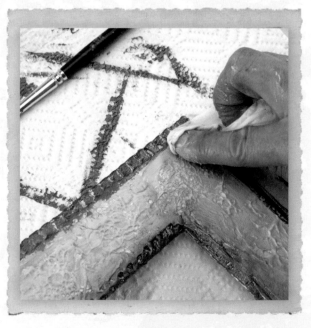

13. Begin painting the flat (non-corrugated) portions of the frame and the doors combining Sky Blue and Classic Teal paints.

14. Using a baby wipe, rub off some areas a bit where you will put the flowers. This creates some depth and contrast. Paint the corrugated edges of all the pieces using copper paint. Rub some of the paint into the blue areas.

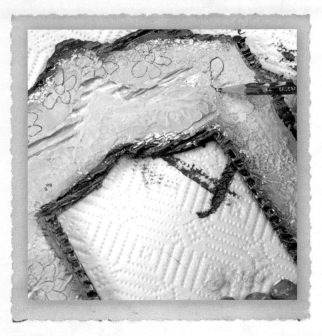

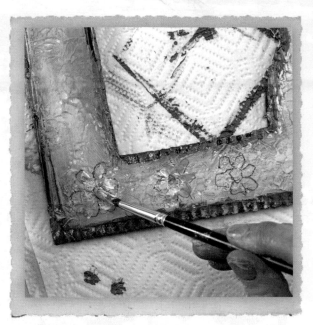

16. Paint the flowers using a combination of Modern Red, Altered Orange and white.

15. With a pencil, draw flowers over the surface of the frame and doors.

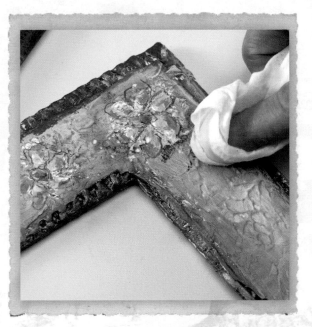

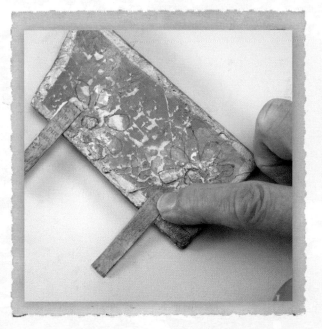

18. Fold a piece of paper with text on it in half and glue the two layers together with gel medium. Paint it with a diluted wash of copper paint. Give it a coat of gel medium, let it dry, then cut it into eight $\frac{1}{4}$" x 2" (6mm x 5cm) strips. Glue one strip to the top and bottom outside edge of the door.

17. In some areas, scribble with a dark teal watercolor crayon and blend it in with a rag or your finger.

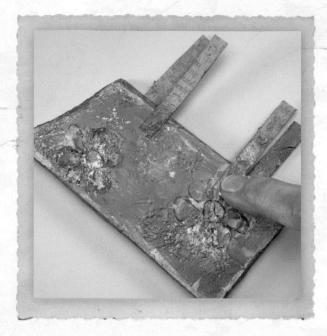

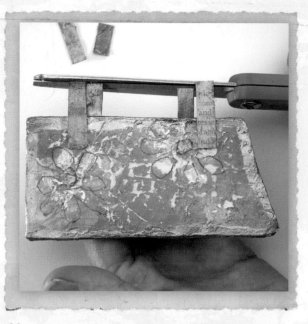

19. Turn the door over and glue two more strips to the back.

20. Trim the strips to leave a ¾" (19mm) overhang on each.

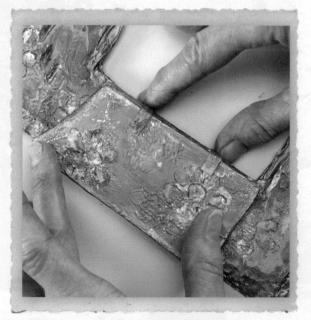

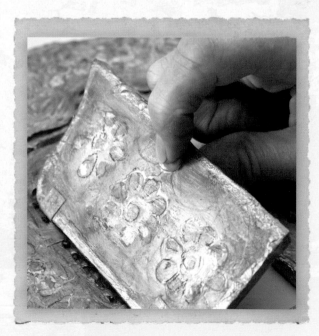

21. Put glue on the underside of each strip and glue them to the front and back of the frame. Repeat this process for the door on the other side of the frame.

22. Glue small pearl buttons to the doors for doorknobs.

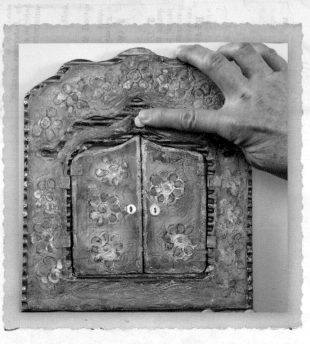

23. Glue a larger button above the door.

24. Cut a piece of matboard to 6½" x 7" (17cm x 18cm), and collage one side with text using a final coat of gel medium over the entire surface. On the other side, apply white gesso and then paint with a mixture of Sky Blue and Classic Teal. When the paint is dry, cut ¼" (6mm) wide matboard strips, and glue them down using gel medium just inside the board edge on the two sides and bottom. Glue the strips to the back of the frame with the open side at the top.

25. Glue a beverage pop top to the back for your hanger.

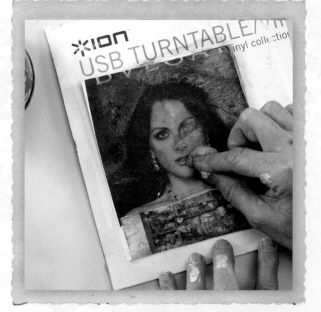

26. For the painting, measure and cut out a piece of watercolor paper the correct size to fit inside the frame. Glue a magazine image of a face to the paper with gel medium. Layer and glue down additional magazine elements if you like. Rub a piece of Nevr-Dull over the face to lift up ink and obscure facial features.

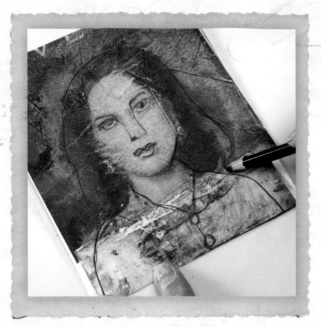

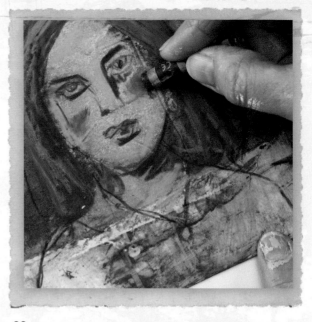

27. Sketch in altered features with a pencil. Apply a coat of clear gesso over the entire piece to give it some tack.

28. Use watercolor crayons to apply color in specific areas.

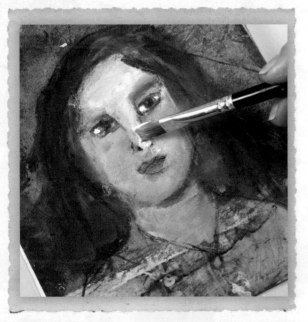

29. Blend white paint with the crayon, creating light and dark tones. You can use a brush or your finger for this. After the crayon is worked in, you can paint in additional details.

30. When you're finished, you may want to glue down text or a poem. Slide the painting into the frame and it's ready to hang.

Riding the Waves of Imagination

I attached metal wings to the doors to give this piece a whimsical feeling—a flying house with a painted girl inside.

Discover

Poetic Purpose

Volunteer to teach a small group of children or adults how to make simple collage and painted artist trading cards (ATCs) that they can give to others they meet—ambassadors of inspiration.

Book of Haiku

Spreading Inks, Sgrafitto and Finding Hidden Images

This project is designed to be spontaneous and experimental—to spark your curiosity and joy of the art-making process. I suggest using a large sheet of watercolor paper and working each technique in sections over the page, but really, working on smaller sheets is fine. Hot-pressed watercolor paper will perform differently than cold-pressed paper, and I encourage you try techniques out on both to discover the differences and compare the results.

The techniques I'll share with you are often used in the world of watercolor painting, and with them you can achieve a variety of colorful effects. When dry, study your paintings as you would a cloud-filled sky, discovering hidden images that reveal themselves to you, then further define them with additional colors and lines. Once your painting is finished, share your experience of the painting with words in the poetic form of haiku. You may want to handwrite the poem with a fountain pen and ink or marking pens, use alphabet stamps with ink, or glue on found words.

You can't use up creativity. The more you use, the more you have.
— *Maya Angelou*

Supplies to Gather

- ice cube tray or series of small containers
- fluid acrylic paints, assorted colors, including: Metallic Bronze, Hansa Yellow, Napthol Red, Phylo Blue
- assorted water-soluble inks
- paintbrushes
- water container
- watercolor paper
- spray bottles
- tissue paper
- soft gel medium
- eyedropper
- cotton cloth
- salt crystals
- Acrylic Flow Release (Golden)
- white gesso
- old toothbrush
- plastic wrap
- skewer or sharp stick
- scissors
- clear gesso
- no. 6B graphite pencil
- black and white gel pens
- red paint marker
- matboard
- cutting mat
- craft knife
- fabric strips
- rotary cutter
- straight edge
- waxed linen and tapestry needle
- fabric glue

Expression Direction

Contemporary haiku is made up of three lines and up to seventeen syllables. Although the syllable count isn't adhered to strictly, the general rule is five on the first line, seven in the middle line and five again on the final line. These little poems tend to feel light and somewhat detached—regardless of subject— and describe genuine feeling rather than ideas or any sort of judgment. What makes a haiku read differently from a sentence is something called "cutting." The cut comes at the end of the first or second line and is often, but not always, followed by a dash. The cut separates and pits two lines against each other and yet holds a balance between them. For more about haiku see the Resources section on page 124.

Put on some meditation music and spend twenty minutes writing haiku as you listen. Write on any topic that comes to mind. Some ideas are: what you see outside, the weather, your state of mind, your pet, children, your body, the season, a common object in your view, something within arm's reach, your hands or other body parts, the sky, trees, or plants in your yard.

Two haiku examples:

Traditional:
An old silent pond...
A frog jumps into the pond,
splash! Silence again.
—*Matsuo Basho*

Contemporary:
Snow in my shoe
Abandoned
Sparrows nest.
—*Jack Kerouac*

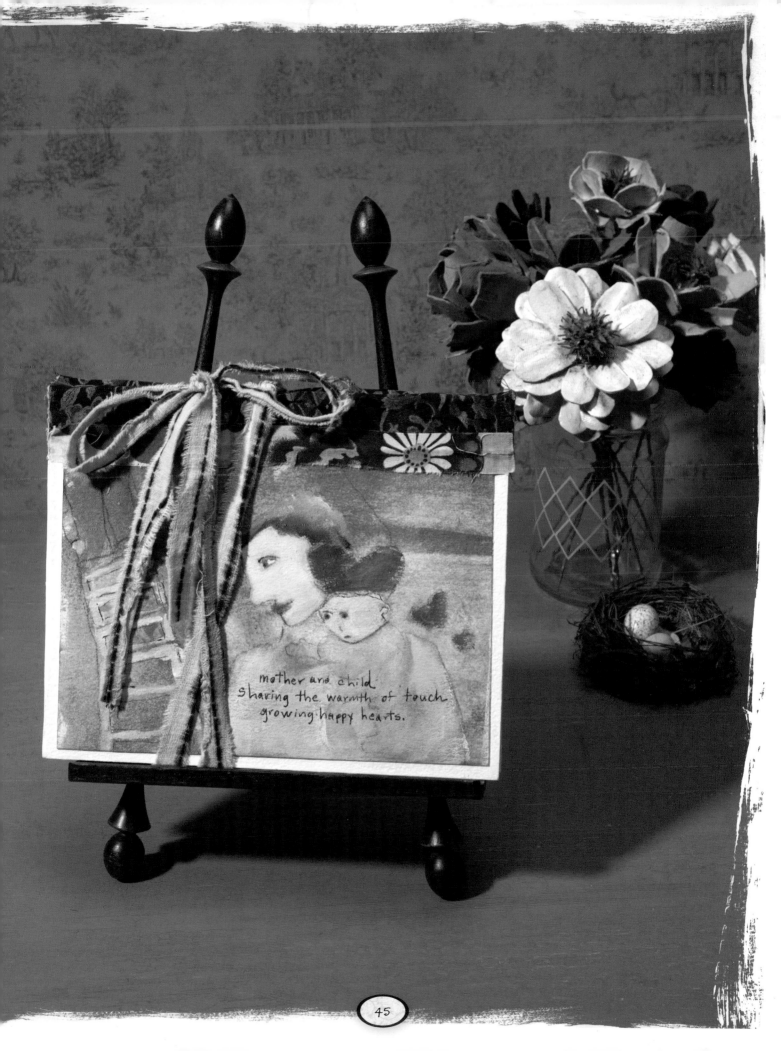

mother and child
sharing the warmth of touch
growing happy hearts.

There are many techniques you can play with in your Book of Haiku. Here are some of my favorites.

Tissue Paper Texture

Wash a few colors onto your watercolor paper—make sure it's diluted and plenty runny. You can tilt your paper so the colors run into one another. Scrunch up some tissue paper and cover the area, pressing it flat. Set it aside to dry a bit but not completely or the paper will stick to your painting. Lift a corner of the tissue paper to see if the design is set and then peel it back.

Plastic Wrap Texture

Wash two or three diluted colors across your paper using a large brush and then lay a sheet of crinkled-up plastic wrap over the wet paint, adjusting it and playing with the raised and flattened shapes until you're pleased with the texture. Lay it aside until it is dry or almost dry, then peel back the wrap to uncover a surprising and colorful effect.

Salt Crystals

Sprinkle salt crystals over wet paint, let it dry, then brush them off with your hand or some utensil. Try a variety of salt crystal sizes for varied effects: Epsom salt, table salt, rock salt, sea salt, etc.

Rubbing Alcohol

Try using a spray bottle to spray rubbing alcohol over wet paint, then watch it move and the shapes change. Use an eyedropper or drops from a cotton swab for the "fish-eye" effect.

Stamping and Sgrafitto

Sgrafitto is an Italian word that indicates scratching through a layer to expose an underlayer. Layer a wet wash of paint, let it dry just a short time, not completely, and then scratch a design into it with a sharp object. The paint adheres to the raw paper scratches darker than it does to the flat surface. Use moderation with this technique, being careful that you don't wear through the paper.

A piece of sponge makes a great stamp, as do other objects that you can dip into wet paint and press onto the paper.

Acrylic Flow Release

Drip or paint some thin lines of flow release onto your paper and then puddle diluted paint onto your paper—it acts as a resist. You can form some interesting patterns when you do the plastic wrap technique over the flow release/painted paper. Weight it down with a heavy book, let it dry some (the flow release makes it take a lot longer to dry) and then peel back the wrap to reveal your design.

Collage

Incorporate assorted papers and images onto your painted page.

1. Use an ice cube tray, a pill book or a collection of cups to put several colors of fluid acrylic paints or inks in. Dilute them with water. With a wide brush, apply a wash of several colors to a portion of dry watercolor paper.

2. Now wet a section of paper with your spray bottle filled with water and wash some colors over it. Notice how the wet and dry papers pick up the paint differently.

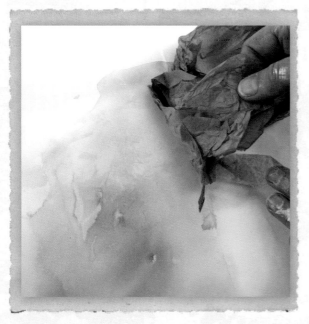

3. Scrunch up a piece of tissue paper and press it onto an area of pooling paint and leave it there until the paint is almost but not quite dry. Peel up the tissue to reveal the patterns it left.

4. In another area, brush on a layer of soft gel medium. When it's dry, use an eyedropper to drip several paint colors over it and tilt the paper to move the paint streams in various directions. Use a brush to blend some areas.

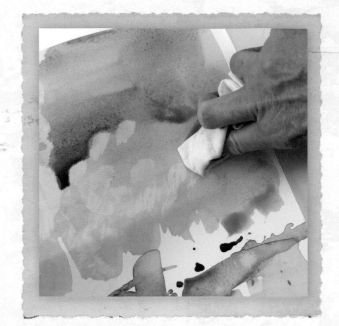

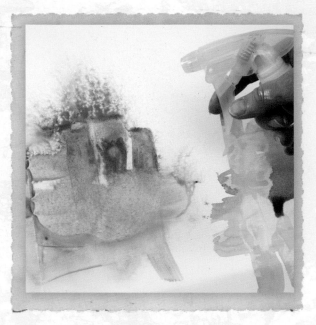

5. On dry paper, use your brush to paint a wash of a few colors, overlapping some areas. Use a scrunched-up cotton cloth to pick up some areas of paint—another way to form patterns.

6. Brush Metallic Bronze onto a dry area of paper and immediately spritz it with water from a spray bottle. The paint will separate out as metallic bronze pigment and a beautiful green patina.

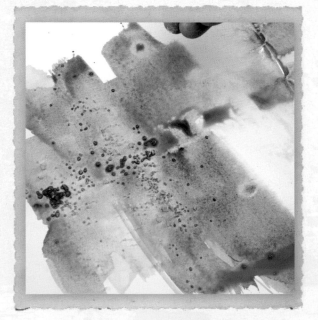

7. Paint a wash of colors on dry paper and sprinkle it with salt. When it's dry, brush off the salt to reveal the design. You will get different results with different crystal sizes.

8. On a dry section, paint a simple design using a brush dipped in Acrylic Flow Release. Brush on colors; the flow release acts as a resist, so the design you are painting with it will remain visible through the acrylic paint.

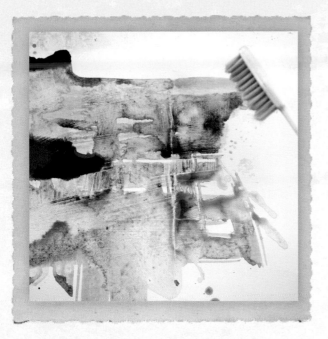

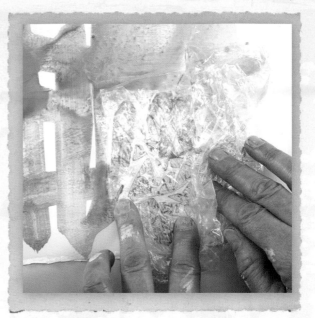

10. Apply soft gel medium to a section of paper and let it dry. Brush on some paint and press on it with scrunched-up plastic wrap. When it's almost dry, pull the plastic wrap off.

9. Paint a layer of gesso on the surface. Brush on ink or paint, then draw lines in it with the back of your toothbrush. Next dip the bristles in pooling paint and flick it off onto the paper in other areas.

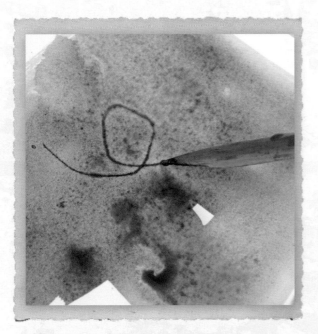

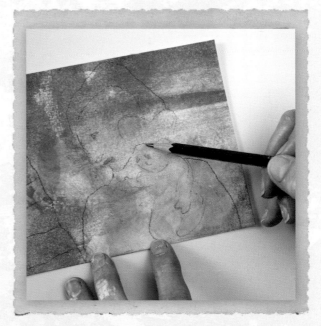

12. Find the sweet spots on your large paper that have promise for your paintings. Cut out eight pieces that measure 5" x 7¼" (13cm x 18cm) and coat them with clear gesso. Use a graphite pencil (I like 6B) to pull out and define the shapes or figures.

11. Brush paint over an area and write in it with a sharp stick or skewer.

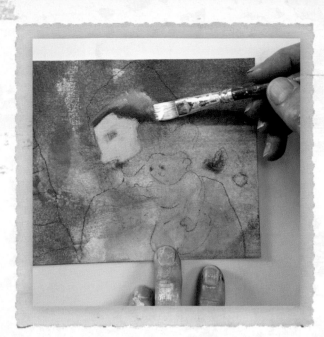

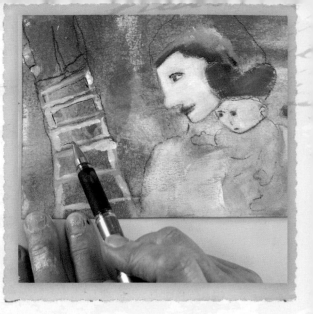

13. Once you have your drawing, begin painting areas, whitening some and darkening others. I usually start by adding flesh tones to any faces and then add general areas of color.

14. I use both black and white gel pens to bring out details and accent small areas. The white pen is great for coloring the whites in the eyes as well as drawing lines on dark painted areas. The black works well for defining details and outlining objects.

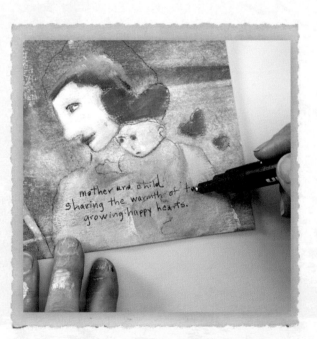

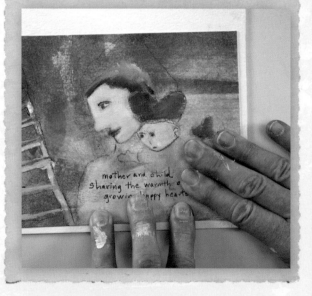

15. Add your haiku to the page in any way you'd like. Here I'm using a black gel pen and a red paint marker.

16. Cut four pieces of matboard 6" x 7½" (15cm x 19cm). Paint a 1" (3cm) swath of white gesso around the edges of the matboard on both sides and let dry. If you want your margins to be a color rather than white, do that next. Line your eight paintings up in order; one will be on the front cover, one on the back, and the rest somewhere inside. Once you determine the order, use gel medium to glue the paintings onto the matboard, leaving ¾" (19mm) of matboard on the spine edge showing and centering the edges on the other three sides. Keep in mind that the spine edge on one side will be on the opposite side on the back of the page.

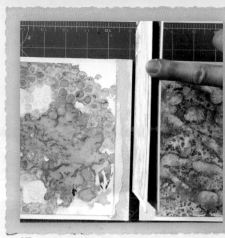

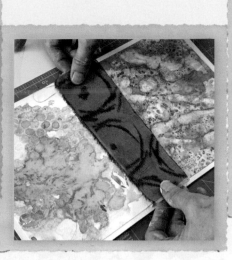

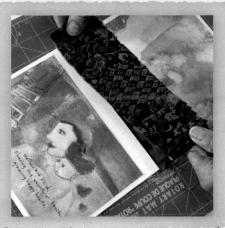

17. Lay out the front and back cover boards on a gridded cutting mat with the insides of the covers facing up and both bottom edges even with about ½" (13mm) space between them—enough that the inner signature will fit between them when the book is closed.

18. Using a rotary cutter and a cutting mat, cut fabric to a 2" x 7½" (5cm x 19cm) strip and center the fabric over the two pages, butting the fabric side edges up against the paintings edges, making sure the top and bottom edges are even. Apply fabric glue lightly on the board area and attach the fabric, leaving the ½" (13mm) gap between them.

19. Turn the joined two pages over and glue on another piece of fabric in exactly the same way, down the center. Lay out the remaining two boards and repeat the process, this time leaving a narrower gap between them and using a cloth strip that is ¼" (6mm) narrower.

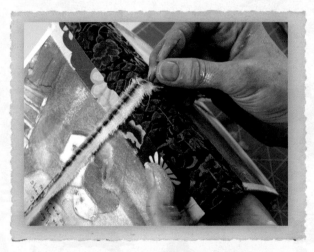

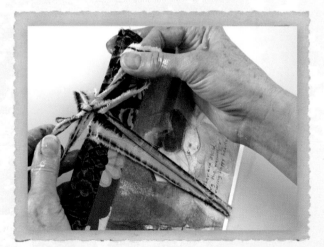

20. If you like, you can glue an additional layer of fabric over the first for interest. Layer the two folios in the appropriate order of the finished book, fold it on the cloth spine and make sure the pages fit snugly and are aligned. Open them back up, lay them flat in a stack, and using waxed linen and a tapestry needle, start at one end and take ½" (13mm) running stitches along the mid spine, sewing across the middle of a 36" (91cm) long fabric strip or ribbon that will serve as a book tie.

21. Continue sewing to the bottom of the spine and knot it on the inside. Wrap the tie around the book twice and tie it in a bow along the spine.

All Creatures Small and Smaller

I used several different fabric patterns for the spine to create contrast as well as interest.

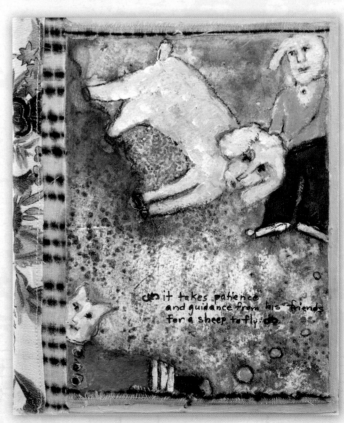

*it takes patience
and guidance from his friends
for a sheep to fly.*

A Little Help From Our Friends

This is the front cover of this book, which expresses that a little giving and receiving help can make all the difference in life—especially when it comes to the difficult things.

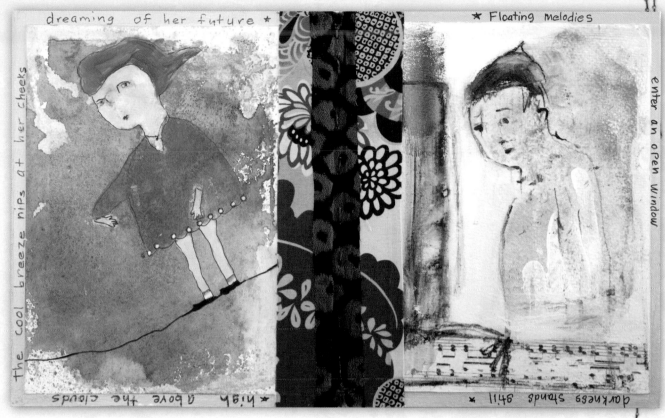

dreaming of her future *

the cool breeze nips at her cheeks

* high above the clouds

* Floating melodies

enter an open window

* darkness stands still

The Balancing Act **Meditation**

The three outside edges on these pages provide a balanced space for writing the three lines of a haiku.

Poetic Purpose

Put together a CD and playlist of your favorite music to create art by and give it to someone creative in your life. Design original artwork for both the CD and envelope, and include a haiku that speaks to the mood of the music.

Lost, Found, Discarded, Discovered

Working on a Grid with Mixed-Media Layers

When we paint intuitively, we can experience a sense of freedom that is without bounds. We can work in a particular direction for a time, then shift to another track with complete abandon. In this boundless, timeless state, we can learn to become aware of the way one brushstroke invites another, and how each mark made is leading a trail to the next. There is no hurry to get to the finish because we get to experience how all the juice is right here in the process, how painting equals passion. That is the intention behind this project.

First you'll tear, cut and glue papers down, completely covering your substrate—a great way to warm up before painting. Even if most of your collage papers end up covered with paint, the process relaxes the mind while adding a first layer of color and texture. You'll initially start by working in a grid, but don't let that fool you—orderly art is not what we're going for. I encourage you to move across lines, put down layers, meander with your brush or finger. Find joy in making your marks. The ultimate goal: Take time to lollygag between each brushstroke and charcoal line, allow yourself to dangle for a time from a sturdy branch of subtle shadow, throw your intentions into pools of pure color, allow The Flow to take you where it will.

> **When you start a painting, it is somewhat outside you. At the conclusion, you seem to move inside the painting.**
>
> —*Fernando Botero*

Supplies to Gather

- collage papers
- gel medium
- substrate of your choice
- clear gesso
- no. 6B graphite pencil
- Stabilo pencil
- charcoal pencil
- Sumi ink
- stick or skewer
- acrylic paints, assorted colors
- palette paper
- palette knife
- water container
- paintbrushes

Expression Direction

Write a poem about yourself using the following phrases:

What you can't see is . . .

What you don't know is . . .

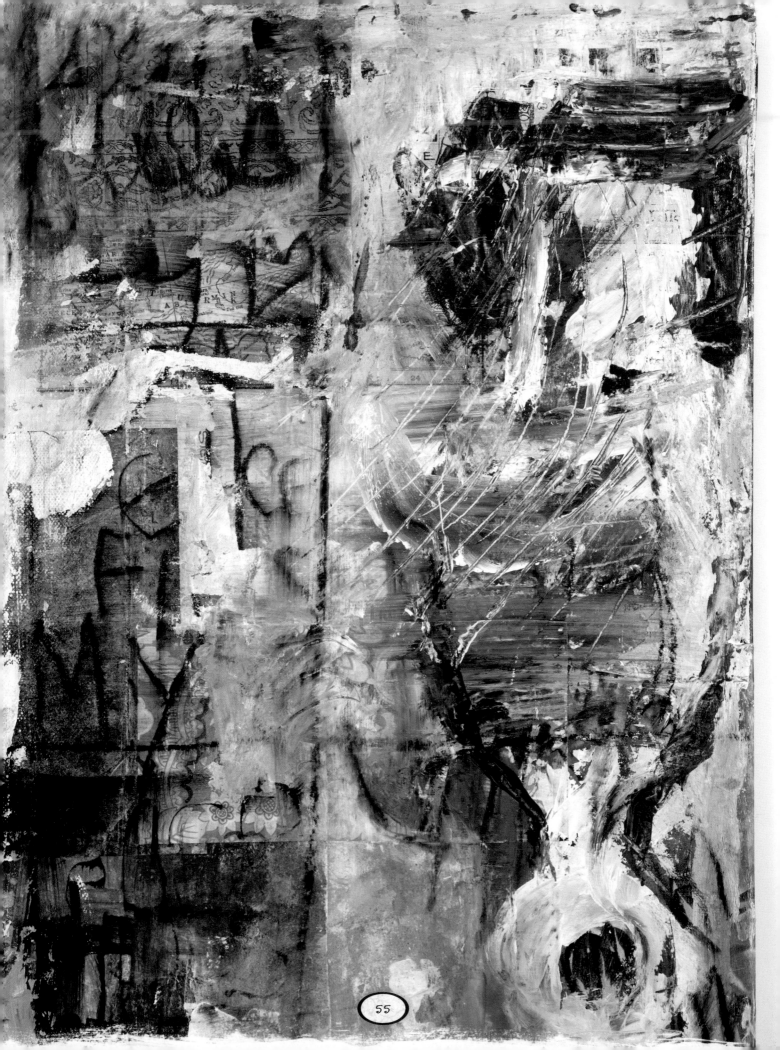

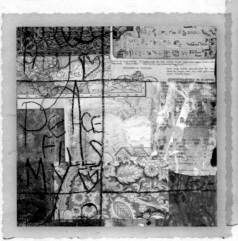

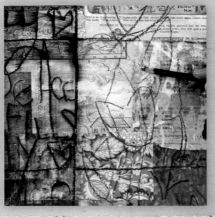

1. Glue down collage papers with gel medium, enough to cover your rigid substrate. (I often use a large recycled book cover, but matboard, canvas panel or any surface will do.) Coat the surface with clear gesso. When dry, draw a two-column grid with your 6B pencil, slightly off-center, with three squares in each column. With your non-dominant hand write or draw with a Stabilo pencil, in the top left box. In the center, still using your nondominant hand, draw with a charcoal pencil, and, in the bottom box, with a stick dipped in Sumi ink.

2. When dry, apply a layer of clear gesso over what you wrote. It will smear a little; that's fine, just don't overwork it. Begin drawing with your nondominant hand again in each of the squares in the right column, using whatever media inspire you. You may want to illustrate some aspect of what you wrote about in the left column or maybe draw a shape illustrated on the collage paper, repeating it in a different scale. Have one of your drawings fill up two of the boxes.

3. Now mix up a little paint on your palette and begin painting with your palette knife. Choose colors that will complement the collage papers. Here I'm using Phthalo Blue (Green Shade) and Raw Sienna. Let your drawing direct your painting. Fill in some areas with paint and leave other areas open. Listen to the voice of your intuition, the "what if I do this . . ." voice that will speak to you when your mind is empty and free of self-judgment. Let your palette knife travel where it will, or use your fingers as brushes to move the paint.

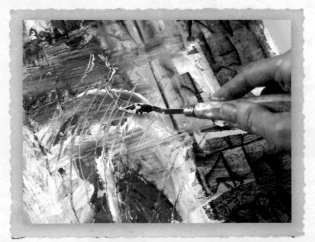

4. Continue to add additional color to your painting and paint over areas that don't work. A palette knife can be used to scratch lines into the surface. You may end up covering all your words and collage papers with paint; that's how to build up layers and find a focal point in the piece. Try turning the painting to view it from a different perspective (you've got four to choose from). If you find yourself feeling frustrated or tense, uncomfortable with the "not knowing," get up and walk around a bit, stretch, sit down, take three deep breaths and re-enter the beginner's mind. Be patient and watch the magic happen.

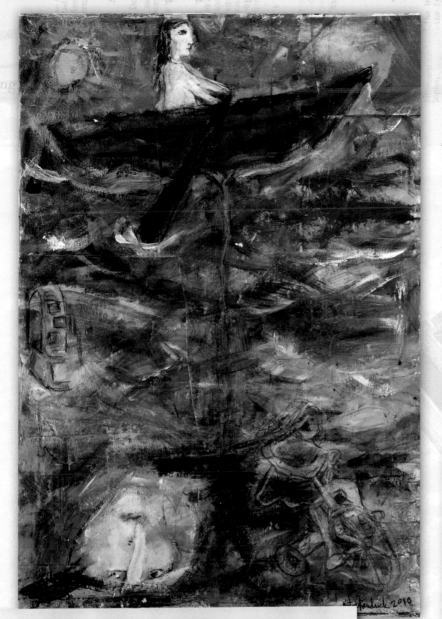

Moving Through the Past

Even though I started with mark making and painting in a grid framework for this painting, various images began to surface the more I worked on it—images from my childhood, memories and dream symbols. The boat, a recurring symbol for me in both my dreams and my art, holds me and moves me through life, protecting me and keeping me connected to Mother Earth by an endless golden cord. The sun is there, an ever-present Light to guide me. When the girl-in-the-boat painting was complete, using stamps and inks I wrote a poem on the back to describe my journey.

Poetic Purpose

Do a purge, gathering discarded items from your garage, closets, drawers and cupboards. Put the word out to friends and neighbors asking for their discards. Work with a specific organization or enlist the help of other volunteers to put together a garage sale, with all proceeds going to your neighborhood food bank or another local charity.

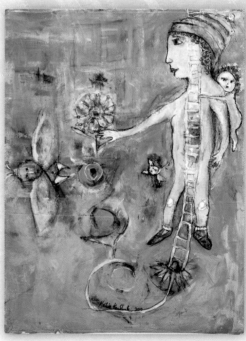

Source

This also started out as a grid painting that morphed into a visual affirmation of my creative connection to the earth and spirit.

Under the Influence
Looking to the Masters for Inspiration

Have you considered what attracts you to a particular painting or artist? Being aware of some of these elements will allow you to consciously work on bringing some of these out in your own work. Here are some questions you might consider when looking at a piece of artwork: What is it specifically about the artwork that you are responding to? Is it the use of color, line, contrast, texture, the simplicity or complexity of the piece, the emotional resonance, the subject, or the story? Who are some of your favorite artists?

One of the ways I approach the blank canvas is by drawing inspiration directly from a painting I like. This doesn't mean trying to reproduce the painting; it means gathering specific information about a technique, quality or mood that I can tease out and play with in my own unique way.

I place the painting near me at the worktable and begin to identify the elements of the piece that draw me in. Once I decide which elements I want to concentrate on, I sketch out a simple version with my graphite pencil. Once I have a rough drawing, I start painting, allowing myself plenty of room to change anything or everything in my initial plan as the piece evolves. Remember, hold your initial plan loosely and, once you've started, let your painting tell you where it wants to go.

> **Every artist dips his brush in his own soul, and paints his own nature into his pictures.**
> —Henry Ward Beecher

Supplies to Gather

- image that inspires you
- watercolor paper
- clear gesso
- graphite pencil
- joint compound or modeling paste
- palette knife
- PanPastel painting pastels
- watercolor crayons
- acrylic paints, assorted colors
- palette paper
- paintbrushes
- water container

Expression Direction

Choose a painting you like and want to work with. After studying it for a while, write a list of words and phrases that capture the essence of the piece. Write a poem using words from the list. Chose a title for your poem and tape it to the back of your "Inspired by . . ." painting after you finish it.

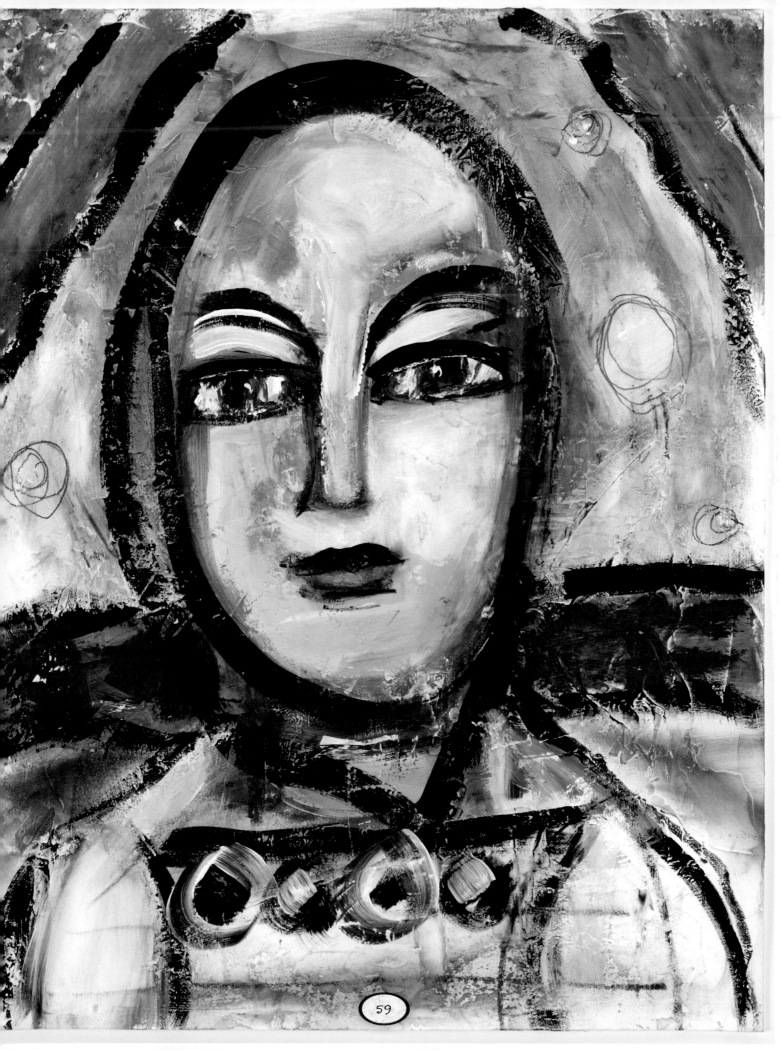

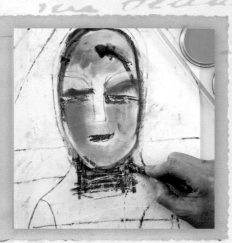

1. Using the same painting that you worked with in the Expression Direction, identify elements that you want to experiment with in your own painting. Cover a blank sheet of watercolor paper with clear gesso. In the painting I've chosen here, I'm inspired by the simple, almost primitive quality of the face, the broad black lines, the color palette and the texture of this face. After I identify those elements, I sketch out a basic drawing with pencil.

2. Using a palette knife, spread joint compound thinly over the surface of the sketch to build in texture. You could also use modeling paste for this.

3. Block out some large areas of color with PanPastels and then follow up by coloring in some areas with watercolor crayons.

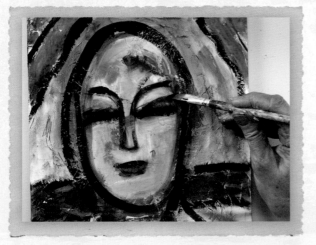

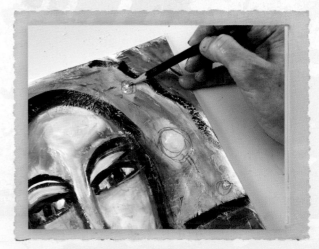

4. Brush on acrylic paint, blending into the previous media. I paint in heavy lines with black paint.

5. Add final details with a pencil.

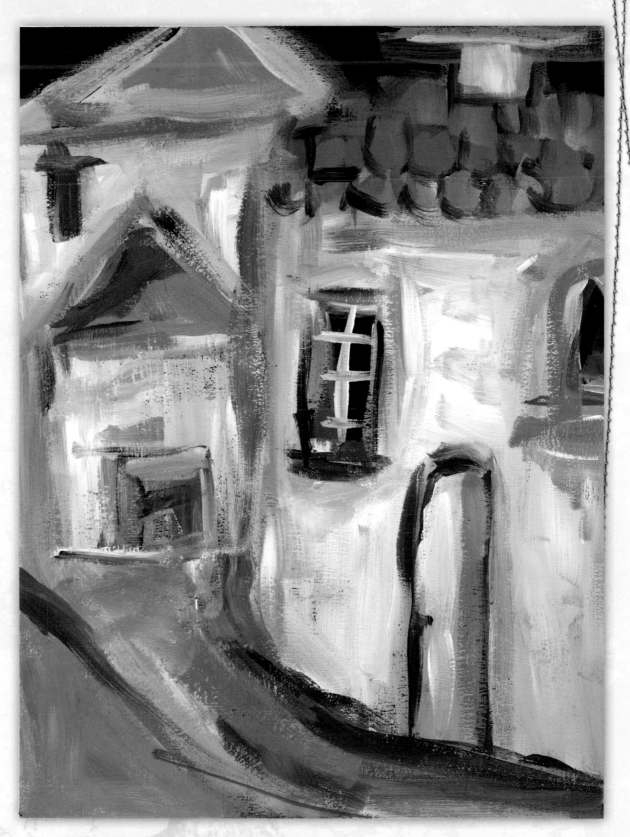

My House is the Smaller One

For this painting, my inspiration was a painting of a village scene. I chose a limited palette in earthy colors, and experimented with laying down color in a painterly fashion without sketching anything out first. I studied building placement and changed it up to make my own unique scene.

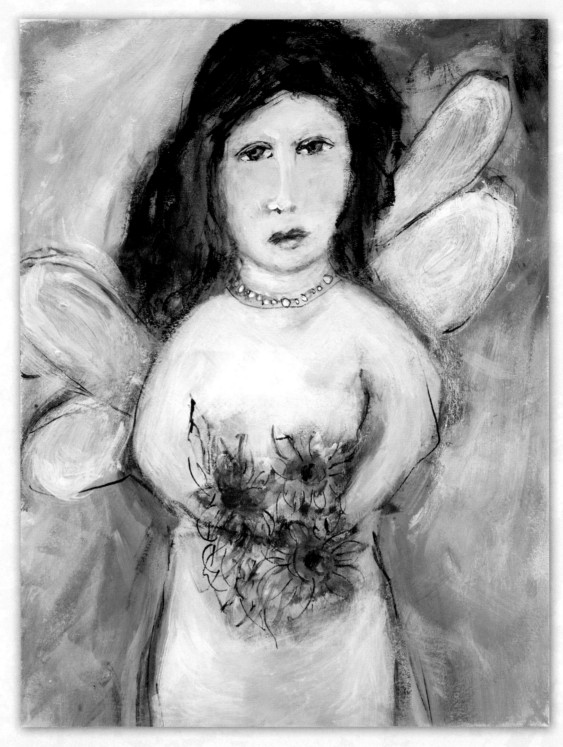

Queen Bee

My goal with this painting was to achieve a soft, dreamy background inspired by a Chagall painting. I used PanPastels and sponges to lay down the color and black Sumi ink for the line work.

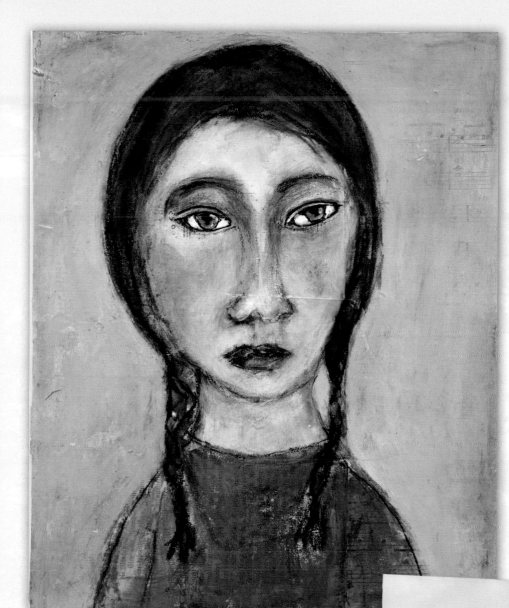

The Artist

The elongated faces of Amedeo Modigliani and Andrew Wyeth's "Helga" series were my inspiration for this young woman. When I look into her eyes, I see an introverted and thoughtful creative soul.

Poetic Purpose

Write a letter of appreciation to someone who has touched your life deeply and is still alive, identifying the ways your life has been influenced by him or her. Create a handmade envelope made from original artwork. Send the mail art to your recipient. Mail-art also touches the lives of postal workers, on its journey.

Self-Portrait Collection

Journaled Reflections in Paint, Collage and Writing

Working in this book can be like looking in a mirror, reflecting back to you different aspects of yourself. This is the journal I pull out when I want to write poetry, prose or art specific to my inner journey. Turning the pages in my book you would see a variety of self-portraits such as altered photographs, paintings, collage, poetry and writing. Tucked inside the envelopes, hidden from view, is writing I feel is too personal for public viewing.

As you create the collages in the Expression Direction, you will discover symbolic representations of your own personal qualities, goals and dreams. I suggest that you design your small collages on envelopes, with pockets to conceal your most private writing, photographs and personal ephemera.

If you don't have the right size envelopes, you can easily make your own by folding a rectangular piece of paper in half the long way and cutting it down as needed to fit onto the page. Once positioned there, sew along the side edges and across the bottom, attaching it permanently to one side of the folded page. If you don't want to sew it, use glue, tape, fasteners, rings or another creative alternative.

When choosing papers for the pages, I suggest using several different kinds to mix and match in each signature. Some of my favorites include: assorted watercolor papers, both blank and inked (see demo photo); map pages; recycled paper bags; wallpaper and envelopes—both new and recycled. I'm sure you can think of others.

> **I paint self-portraits because I am so often alone, because I am the person I know best.**
>
> —*Frida Kahlo*

Supplies to Gather

- book boards, 2 cut to same size
- box cutter
- cutting mat
- magazines, envelopes, watercolor paper and other papers, Tyvek, vintage text
- gel medium
- Elmer's Glue-All
- sewing machine
- skewer or chopstick
- papier mâché clay (see recipe, page 68)
- heavy corrugated cardboard
- water container
- sanding block
- face mask
- self-portrait photograph
- scissors
- credit card or small scrap of matboard
- white gesso
- Stabilo black pencil
- paint pens
- watercolor paper
- punchinella
- inks in spray bottles
- paintbrushes
- spray bottle of rubbing alcohol
- Sumi ink and walnut ink
- collage papers
- envelopes (you can make your own)
- waxed linen thread and binding needle
- awl (optional)
- latex gloves (optional)

Expression Direction

Look through magazines and cut out images that appeal to you, ten for each of these three categories: People, Places, Things. Spread them out into separate piles. Choose one item from each pile and create a collage with the group, gluing them onto a large envelope that will become a page in your book. On a separate piece of paper, write a poem based on the collage. You can place the poem inside the envelope or include it on a page.

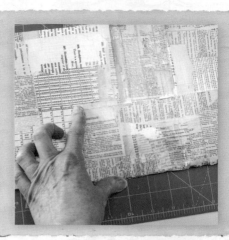

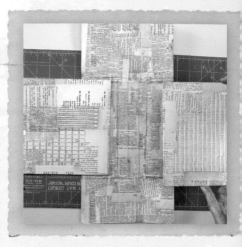

1. Using a box cutter, cut two square book boards; for this project mine are 7½" (19cm). Cover both sides with a variety of torn pieces of vintage book text, using gel medium to glue them down.

2. Cut a piece of Tyvek long enough to wrap around the top and bottom edges of the covers and overlap each other in the middle. Make the width of the Tyvek the width of the spine plus 3" (8cm) for overhang. The piece I've cut here is 7" x 16" (18cm x 41cm). Use gel medium to glue text onto both sides of the Tyvek.

3. When the text-covered Tyvek is thoroughly dry, you can create added interest by sewing vertical lines in the spine area with your sewing machine. Lay the spine on a cutting mat along one of the grid lines. Glue the covers to the Tyvek spine on each side of the 3" (8cm) center designated for the spine, aligning the top and bottom of the book boards.

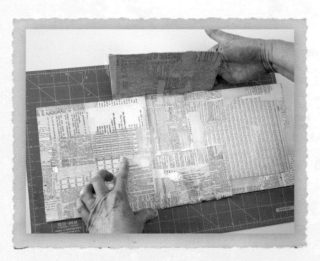

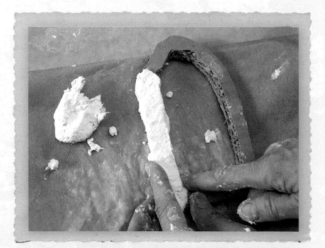

4. Once dry, flip it over and spread glue on the overhanging top and bottom flaps of Tyvek and fold them over onto the covers. Use a skewer or chopstick to press the spine paper into both front and back board edges where they meet.

5. Mix up a batch of Papier Mâché Clay (see recipe, page 68). Cut a cathedral window shape from heavy corrugated cardboard and cover it with the clay, doing small areas at a time. Dip your fingers in water to smooth the clay as you work.

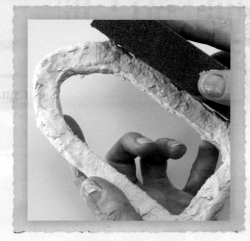

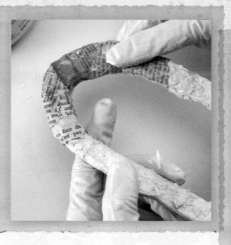

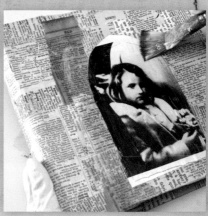

6. Let the clay harden naturally, or bake it in the oven at 150° for a couple of hours or until it is hard and dry. Sand the hardened piece with a sanding block; be sure to wear a face mask to prevent inhaling dangerous particles.

7. Cover the sanded frame with torn pieces of text, using a generous amount of gel medium.

8. When dry, use your frame as a template to draw around a self-portrait photograph and again on the front cover as a placement guide for your image. Cut the picture out, just inside the pattern line. Use gel medium to glue your image to the cover, burnishing it with a credit card or a piece of matboard to remove air bubbles.

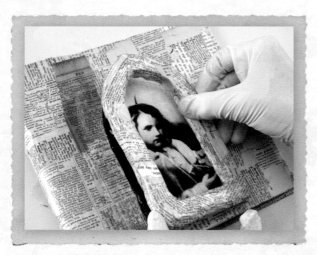

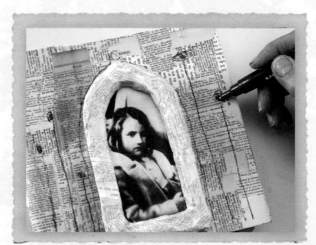

9. Apply gel medium to the underside of your window frame and glue it over your image.

10. Brush a diluted white gesso wash over the window frame. Add any final details to the cover to personalize it. Here, I have drawn simple flowers with a black Stabilo pencil and a paint pen.

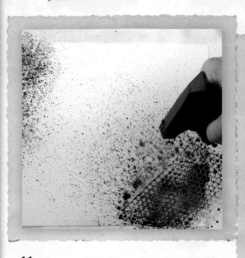

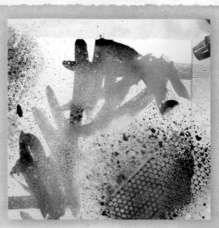

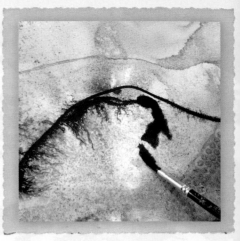

11. To create ink-wash paper, tape punchinella over your watercolor paper and spray some areas with ink. Here I'm using colored walnut ink.

12. Use a paintbrush to apply additional inks and spray with rubbing alcohol to get unique patterns.

13. Let the paper dry a little and then add lines of Sumi ink with a brush or stick. Now you're ready to create your signatures. Before you add them to your book, do any sewing on the individual pages before binding. Sew the collaged envelopes onto the pages on either side of the fold. Stack two or three pages together and sew them into the spine of the book in the same way that you did for the project on page 51.

Papier Mâché Clay Recipe

from *Make Animal Sculptures with Paper Mache Clay* by Jonni Good

ultimatepapermache.com

Ingredients to Gather

- water
- mixing bowl
- 1 roll of cheap toilet paper soaked in water and wrung out (reserve 1¼ cups [296mL] of pulp for this recipe and discard the rest)
- ¾ cup (177mL) of white glue (Elmer's Glue-All)
- 1 cup (237mL) of joint compound (regular, not light or quick-set)
- ½ cup (118mL) of white flour
- 2 tablespoons (30mL) of linseed oil

Soak the toilet paper in water and wring out as much as you can; discard water. Break the paper into small clumps and measure out 1¼ cups (296mL) into the mixing bowl; discard the rest. Add your other ingredients and mix with a mixer for at least 3 minutes until it becomes a pulp. If you see small lumps after that, break them down with a fork or with your fingers and turn on the mixer for a little longer until everything is smooth. Store in an airtight container for up to 5 days. Makes 1 quart.

Poetic Purpose

With the theme "self-portraits," put a call out for participants to be a part of a self-portrait project. Each person will make a piece of self-portrait art and take a high-quality photo or scan and make enough photocopies in a predetermined size for each member of the group plus one. They all send you their copies, and you assemble and bind them into books, one for each participant, and one as a give-away prize on your blog.

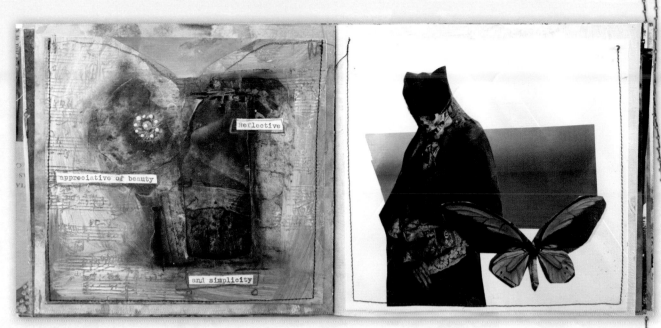

Reflection, Beauty, Simplicity

Transformation

I have completed only the first step on this second page, gluing down my three collage elements

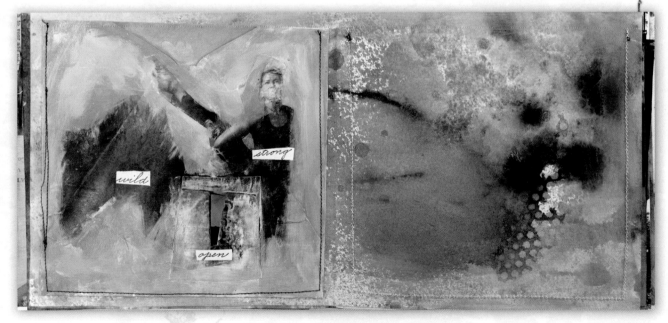

I am Woman

In this collage, I am acknowledging my strength, my open heart and my passionate and wild nature. I glued down found words to represent this and painted in two tones of sage green with gesso rubbed in here and there.

Stories From My Childhood

Illustrating Memories with Collage, Paint and Writing

Use the quote at the right as a platform for your book. Consider what were your favorite movies and TV shows, favorite foods and recipes, paper dolls, real dolls, favorite songs and nursery rhymes, pastimes, make-believes and dress-up experiences. What kind of pillow did you use, what did your blanket look like, did you share a room? What sounds did you hear when you lay awake in bed with the window open on a summer night? Did you have siblings? Were you raised by one or both parents or someone else? Did you have lots of friends or were you more solitary? What outdoor games did you play? Board games? Card games? What activities did you do on long car trips to make the time pass? What were your favorite vacations? Favorite teacher? Favorite grade at school? Did you bring a lunch from home (lunch box or bag?) or buy hot lunch? What did your lunchroom look like? Describe some of the memorable lunch items you remember eating or watching someone eat. What were the memorable activities on your weekends? Did you say grace at the table before meals? Attend church? Walk to school, carpool or take a bus? Think about using the prompts from these things, as well as favorite poems, as a theme for the illustrations, using found objects as closures, and include flat ephemera like copies of report cards or classroom photos from school.

> **There is a garden in every childhood, an enchanted place where colors are brighter, the air softer, and the morning more fragrant than ever again.**
>
> —*Elizabeth Lawrence*

Supplies to Gather

- heavy cardboard
- rotary cutter or craft knife
- cutting mat
- white gesso
- palette knife or similar spreader
- joint compound
- punchinella
- acrylic paints
- palette paper
- paintbrushes
- water container
- face mask
- sanding block
- collage papers
- soft gel medium
- pencil
- ¼" (6mm) cheesecloth strips
- hair dryer
- heavy gel medium
- matboard
- assorted pieces of fabric
- chopstick or skewer
- fabric glue
- credit card for spreading
- scrap paper
- heavy paper
- alligator clips
- awl
- waxed linen thread and tapestry needle
- scissors
- ribbon or trim (optional)
- duct tape
- buttons
- found necklace or leather cord

Expression Direction

Print out three or four of your favorite childhood poems. Circle favorite words and short phrases in each. Write what you circled on small pieces of paper and arrange them to form an original "found" poem. Illustrate a page in your book using your poem as the theme. Save the words in a box or basket for "found" words. Cut words out of books or magazines when you have free time, taping them onto little papers or rewriting them to add to your growing collection.

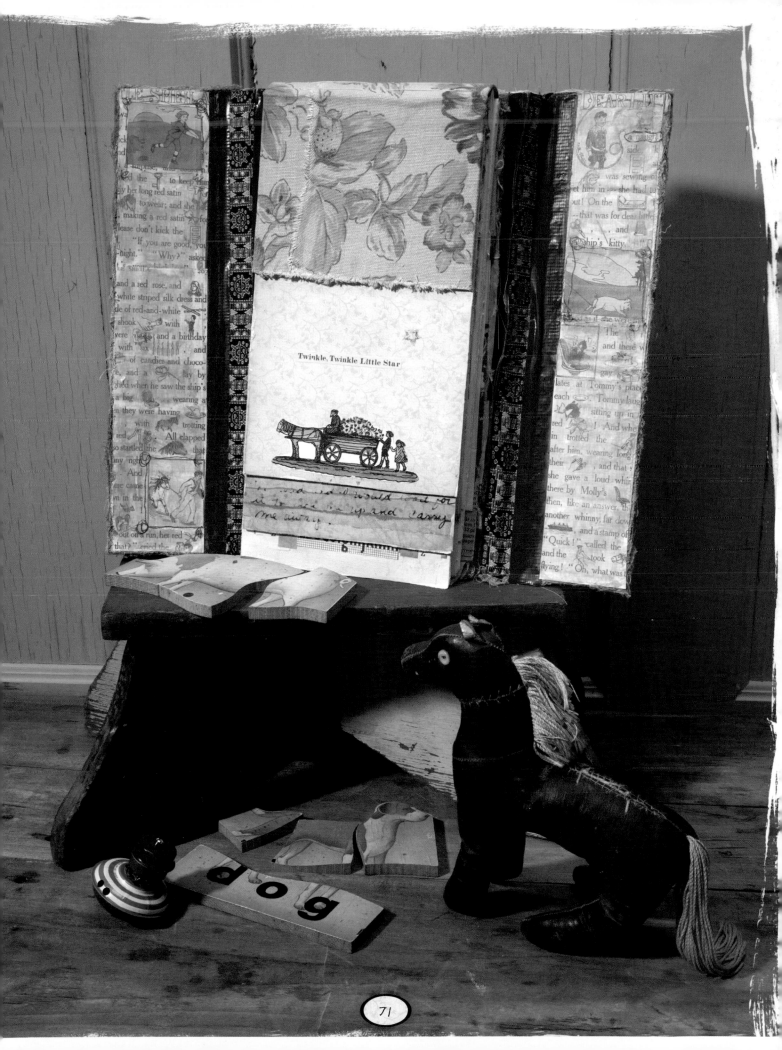

Twinkle, Twinkle Little Star

dog

1. Working with a rotary cutter or craft knife, ruler and cutting mat, cut out three pieces of cardboard: two 3" x 12" (8cm x 30cm) pieces and one 6" x 12" (15cm x 30cm) piece. Coat one side of each piece with gesso and let it dry. With a pallette knife, coat the other sides with a layer of joint compound, thick enough to build in some texture.

2. After the compound has dried a little but is still damp, create some texture by pressing corrugated edges of cardboard into the plaster.

3. Press a piece of scrap cardboard into other areas with the flat surface area, lifting up carefully. Lightly press a piece of punchinella (sequin waste) into a few additional spots.

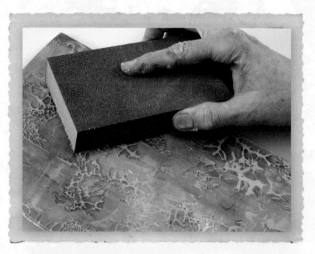

4. When the plaster is dry, brush on a wash of diluted paints in two to three colors, overlapping them in some areas.

5. When the paint is dry, don your face mask and sand off the high areas of plaster with a sanding block to uncover additional colors and patterns below. Paint and repeat sanding until you are happy with the design.

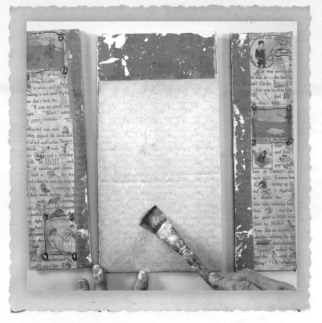

6. Apply collage papers to the other sides of the three pieces. For the middle section I used a decorative vintage paper; for the sides I chose text and other images. After gluing them down with gel medium, I painted on a wash of color and, when dry, drew in some funky pencil lines to give it a more childlike feeling.

7. Decide on a color for your cheesecloth trim. Combine water and that color paint in a dish to dip and dye your cheesecloth. Don't rinse it; just let it air dry or use a hair dryer to speed the drying process.

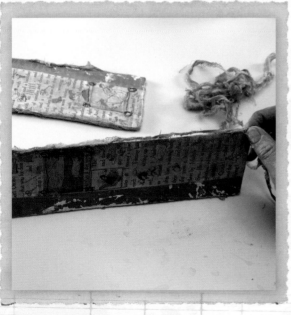

8. Dab on small dots of heavy gel medium to the sides of each cardboard panel. I find it easiest to start gluing an end 1" (3cm) beyond the corner, applying the cheesecloth strip by gently pressing and twisting as I pull it all the way around.

9. Cut three pieces of matboard: two 6" x 4" (15cm x 10cm) and one 6" x 1½" (15cm x 4cm). Glue these to a piece of fabric as shown, leaving ¼" (6mm) between the pieces. Use a skewer to separate and push down on the fabric in the spaces between the pieces.

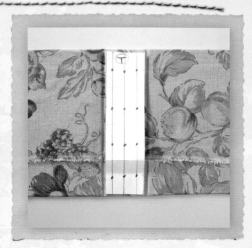

10. Apply fabric glue over the surface of the matboard pieces. Fold the fabric over and smooth it down with a credit card to form a strong bond. If you're using a thin fabric, use the glue sparingly. Burnish the fabric between pieces to create a neat crease.

11. The matboard pieces will be entirely wrapped in fabric when you are done.

12. Cut a piece of scrap paper 1½" x 6" (4cm x 15cm) and fold it lengthwise. Draw one line parallel to each side of the fold, ½" (13mm) from the fold. Fold the paper in half the other way and then into quarters. Make a series of dots in the center of each folded section.

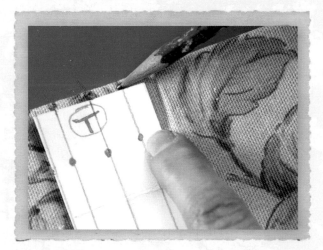

13. Stack interesting pieces of heavy paper together to create your signatures. The folds will line up along the top rather than along the side. The pages will be as wide as your middle cover section, and can be up to 11½" (29cm) long after folding (23" [58cm] total length), so they fit nicely inside the covers. I like to cut shorter lengths as well and stagger them between longer signatures. Stack the folded sheets into three signatures of three pages each. Use an awl to make a hole at each mark, going down the center fold of each signature.

14. Use the paper pattern to make registration marks at both the top and the bottom edges of the spine.

15. Align the first signature to the center of the spine using the registration marks at the top and the bottom as your guide. Use clips to hold the two together and use an awl to poke holes through the signature and spine at each pencil mark.

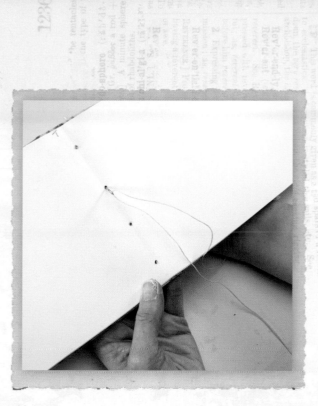

16. Cut a length of waxed linen thread two-and-a-half times the length of the spine. Thread a tapestry needle and, from the inside, insert the needle into the second hole to the outside.

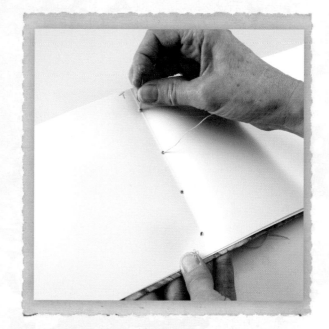

17. Pull through, leaving a 2" (5cm) tail. Next, insert the needle from the outside into the top hole and pull back up to the inside.

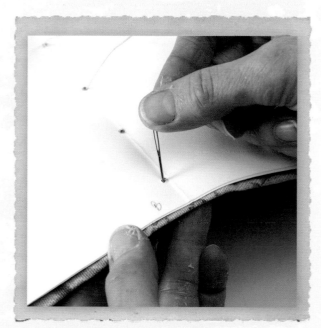

18. From there, pull your thread across the length of the inside and through the bottom hole to the outside.

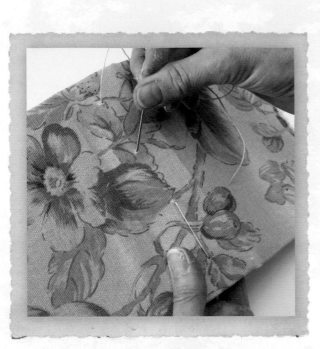

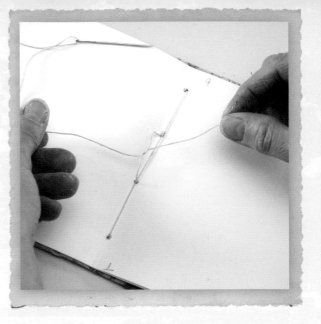

20. Pull both threads away from each other until taut, and then tie a double knot. Clip the tails with scissors.

19. Thread the needle back through the remaining hole from the outside back to the inside.

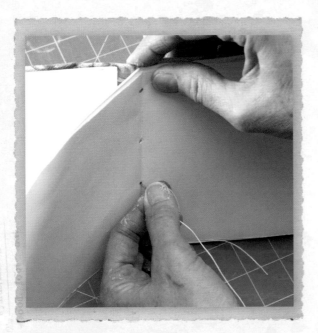

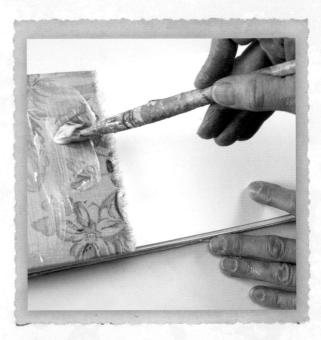

22. Apply heavy gel medium to the back of the signature block.

21. Place the second signature next to the sewn-in signature and poke holes through the signature and spine as you did for the first signature. Clip it in place to secure all the layers and sew them in the same way. Repeat for the third signature.

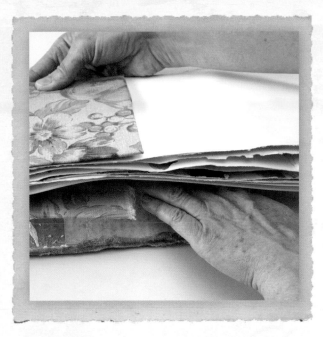

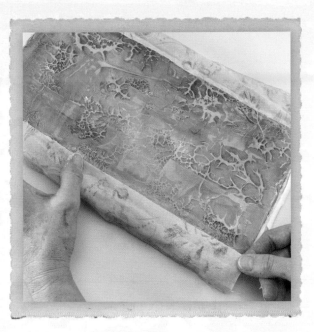

23. Glue the block onto the back panel of the book. You may need to clip the two pieces together while the glue sets to prevent warpage.

24. Cut two pieces of fabric that are the height of the book (12" [30cm]) and wide enough to wrap around the signatures plus 1" (3cm). Spread a thin layer of heavy gel medium ¼" (3mm) wide along the long sides of the back cover. Line the fabric up and press it into the gel medium on the cover.

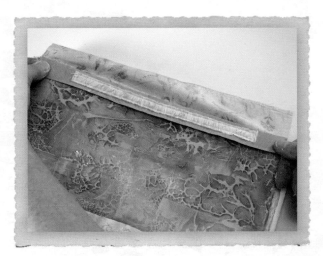

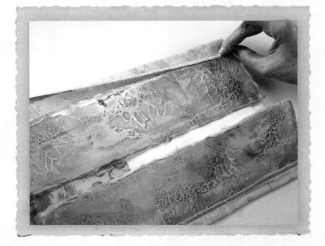

25. Add a piece of ribbon or trim, if you like.

26. When the back section is completely dry, wrap the free edge of the fabric around the signatures and glue it onto the front covers, ¼" (6mm) strip from both edges, just like you did on the back cover. Let it dry completely.

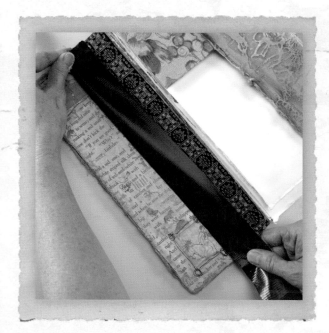

27. On the inside, glue a contrasting strip of fabric down the length of the space between covers. (I did this to hide the wrong side of the fabric. If you have a double-sided design, you may want to omit this step.) Run a strip of duct tape between the contrasting fabric strip and the collaged covers.

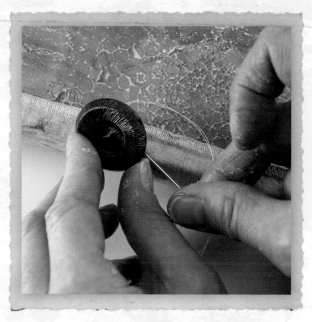

28. Sew buttons to the fabric edges on the front covers.

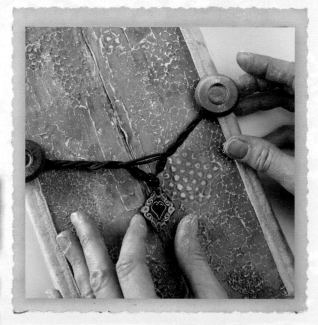

29. Here I used a necklace I purchased at a thrift store to tie my book together. You could also use fabric or leather cord for your ties.

Poetic Purpose

Create a small book of stories and memories for a family member or childhood friend and gift it to them on an "un-birthday."

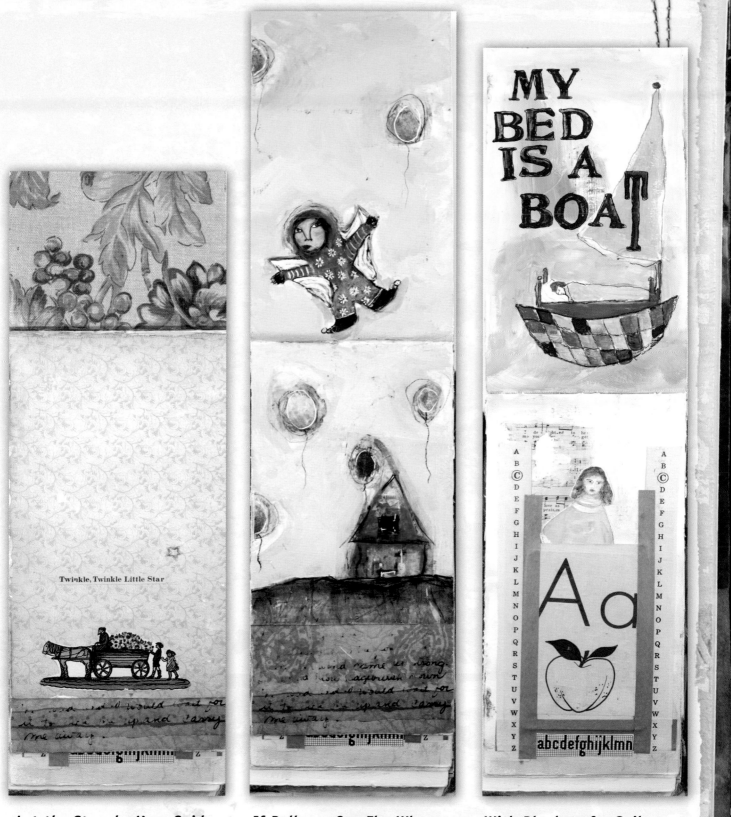

Let the Stars be Your Guide

If Balloons Can Fly, Why Can't I?

With Blankets for Sails

This book, like my childhood, is interspersed with favorite songs and poems as well as imagery that reflects the innocent wonder that bubbles up effortlessly in a child's mind. A vintage flash card made into a pocket holds a handmade paper doll. I think she needs a wardrobe, too; don't you?

Self-Inquiry Visual Journal

Encaustic Incising and Plaster Work

A teacher once told me that personal importance lies in the asking of a question, since getting an answer is out of our control. That statement started me looking at things in a whole new way. This journal is a place to put down your own questions, thoughts and ramblings using images and words.

My cover design was created using objects that held symbolic meaning for me. The ladder and heart represent my journey upward toward higher consciousness. The small mirrors remind me how I can only see a small reflection in the big picture, and the vintage book spines represent the pages of my personal story inside this book, deeply connected to the stories of all who have gone before me.

I used nine tabs to divide my book, with the same headings that are used in the Expression Direction exercise. The exercise generates words, phrases and ideas that you can expand on further through art and writing. Feel free to substitute my headings with your own.

My hope is that you will allow yourself the freedom to move from one topic to another, to write and create art without the need to finish the page spread in one sitting, and to work spontaneously and with passion.

> **Self-inquiry is simple. It does not require you to do anything, change anything, think anything, or understand anything. It only asks you to pay careful attention to what is true and real.**
>
> —*Arjuna Ardagh*

Supplies to Gather

- craft knife
- cutting mat and straightedge
- heavy cardboard
- joint compound
- palette or putty knife
- vintage book spines
- acrylic paints including Raw Sienna
- palette paper
- paintbrush
- water container
- soft paint cloth
- linseed oil
- clear encaustic wax and melting pot
- Burnt Umber oil stick
- wax scraper
- heat gun
- found words
- scissors
- craft mirrors
- Staedtler Hot Foil Pen foil, silver
- pencil or scribe tool
- 140-lb. (300gsm) watercolor paper
- walnut ink
- fabric
- awl
- waxed linen thread and tapestry needle
- symbolic ephemera

Expression Direction

Section a large sheet of paper into a 9-square grid. Place one of the following headings at the top of each square:

1. In this moment
2. What I have learned
3. Reflections
4. Things I want to know
5. Discovering myself
6. The ones I love
7. Comfort
8. Adventures
9. Dreams

In each box write the words and phrases that come to mind when reflecting on each heading. Chose one word or phrase from each box and write a poem. Include the poem somewhere in your book.

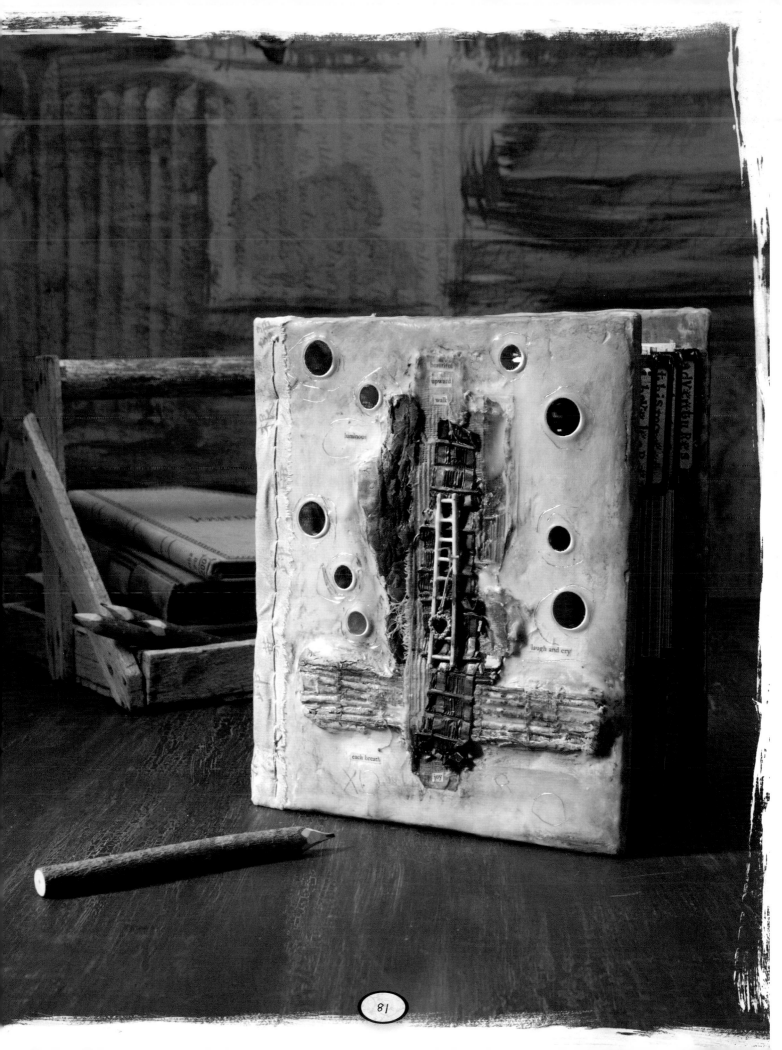

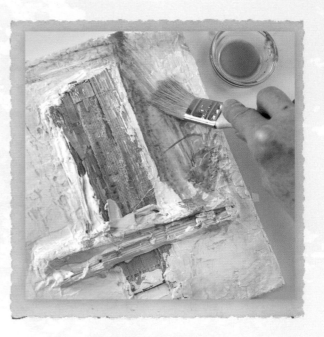

1. Using a craft knife, straightedge and cutting mat, cut two pieces of cardboard for the covers: 8½" x 10" (22cm x 25cm). Cover both sides of each with joint compound. For the front cover, embed an arrangement of vintage book spines.

2. Brush on a diluted wash of Raw Sienna or a similar color, spreading the color over the plaster, lighter in some areas and darker in others.

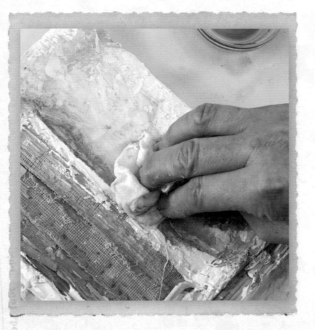

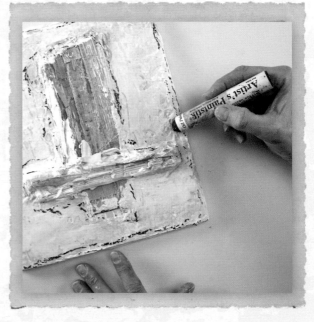

3. Use a soft paint cloth to rub off or blot up the excess color.

4. Use a Burnt Umber oil stick to color the edges of the cover and around the embedded book spines.

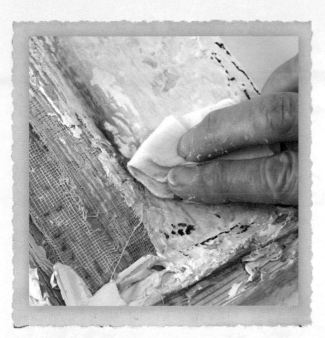

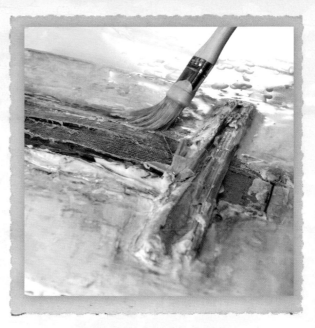

5. Rub the color in with your soft cloth. Dip a corner of your soft cloth in linseed oil to blend more easily.

6. Heat up clear encaustic wax medium in a small melting pot and brush it over the inside and outside of both the front and back covers.

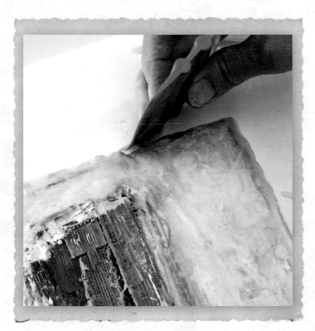

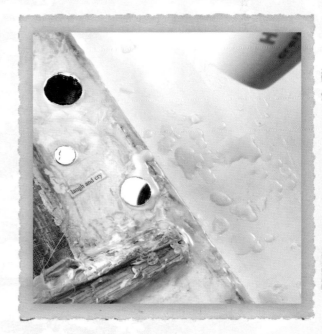

7. Use a scraping tool to remove drips of wax along the edges. Use a heat gun to barely melt the wax again, fusing it to the surface. Apply a second layer of wax and repeat the process.

8. Cut out found words and move them around to find the best placement. Reheat a small area of wax and push a word into it. Apply a drip of wax over it and heat with your heat gun to seal. Don't overheat the area or your wax will melt too much and the word will float away.

　　Use your brush to add small dollops of wax to the spots where your mirrors will go and press them into the wax. Heat the areas around the mirrors to fuse the wax and embed them into the surface. Again, be careful not to overheat the areas or your mirrors will slide around.

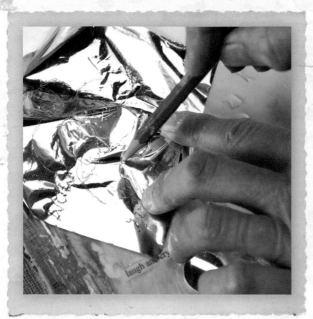

9. To add metallic silver lines around the mirrors, place silver foil—shiny side up—over the mirror. Use a pencil or scribe tool to draw a circular shape around the mirror.

10. Pull up the foil to reveal the silver lines you drew underneath.

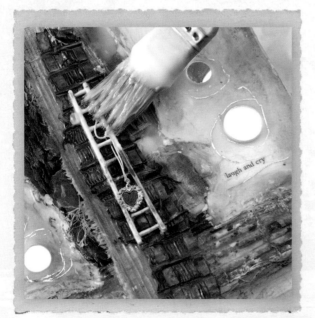

11. Create signatures from 140-lb. (300gsm) watercolor papers. I used a combination of walnut ink painted pages and blank pages. Stack the signatures to calculate the width of fabric needed to cover them and create the spine. Cut a piece of fabric accordingly. Overlap the fabric a little onto the front cover and, with an awl, create holes through both. Use waxed linen thread to sew the fabric to the cover. Pull the fabric over the signatures and connect the fabric to the back cover in the same manner. Once the covers are attached to the spine, sew signatures onto the spine starting with the center signature. (See pages 75–76 for an example of sewing in signatures.) Finally, add any additional symbolic objects to the cover, attaching them with waxed linen thread or hot wax. After the wax is thoroughly cured, allow about two weeks, buff the covers with a soft cloth to bring out a beautiful shine.

Inside cover

Before I coated the inside with beeswax, I carved out my name and "xo" into the plaster with an insising tool. I then rubbed Burnt Umber acrylic paint into the impressions as well as areas of the cover surface, staining some of the plaster and wiping off the excess. For the dividers I found some heavy vintage ones at a garage sale that had nifty metal plates. I stamped the headings on paper using a small set of stamps and black ink. I painted each divider and included each with a three-page signature of watercolor papers.

Poetic Purpose

Refrain from criticizing or saying anything negative to the people you come in contact with for an entire day. Practice listening instead, both to the other person as well as to the thoughts in your own head. Think of something encouraging or supportive to say whenever possible. What questions come to mind in the course of the day as you deal with people in this alternate way? Note how what you say or don't say affects the mood and your own compassion toward others. Jot down your thoughts and questions periodically throughout the day.

Layers of Meaning

Dimensional Work with Cardboard, Plaster and Encaustic Medium

I've been experimenting lately with the sculptural possibilities of cardboard, building up layers to create depth. For this project, I discovered, through trial and error, that it was difficult to cut through more than four or five layers of cardboard at a time with a box cutter or other hand tool. Make sure to change blades in your cutter often as cardboard dulls the blades in a hurry. If you're not making a clean cut anymore and your cardboard is pulling and tearing, it's a good indication you need a new blade.

You'll notice that I use hemp twine to attach the circles. I intentionally leave long twine strands dangling at the bottom because I think it adds an interesting textural element, even more so when they get somewhat (accidentally) covered in plaster.

I've personalized the piece by adding bits of nature that I've picked up on my walks in the woods and along the beach. I softened the shelf platform with a thin layer of moss, and then tucked in found shells, bark and dried flower petals from my rosebushes.

> I deconstruct to construct. I tear stuff down to pieces. I mess things up, just to put them back in order again. Often in a new kind of order. It is like a never-ending flow, and that is what is keeping me running.
>
> —Rut-Malin Barklund

Supplies to Gather

- corrugated cardboard
- box cutter
- cutting mat
- ruler
- Elmer's Wood Glue
- hemp twine
- joint compound
- putty knife
- acrylic paint in ivory
- palette paper
- paintbrushes
- water container
- dried rosebuds and petals
- Mauve oil stick
- soft cloth
- linseed oil
- encaustic medium and melting pot
- wax brush
- heat gun
- awl
- scraps of lace
- bark, shells, moss, etc.
- waxed linen thread and long binding needle
- beads

Expression Direction

Take a walk out in nature. Pick up natural items that call to you: leaves, twigs, bark, petals, grasses, etc. When you get back home, spread out the natural objects you've collected in front of you. As you look at the various pieces, recall the setting and location where you found them. Can you remember the smells, the sounds, the feelings that arose while walking? Write down what you can remember. Now pick up a piece and look at it with a fresh eye, like you'd never seen it before. What do you see? Write this down. Do this for as many of the individual items as you wish or for the collection as a whole. From your writing, pick out a thought, an observation or an emotional state and write a poem that encompasses these. A haiku might work well for this.

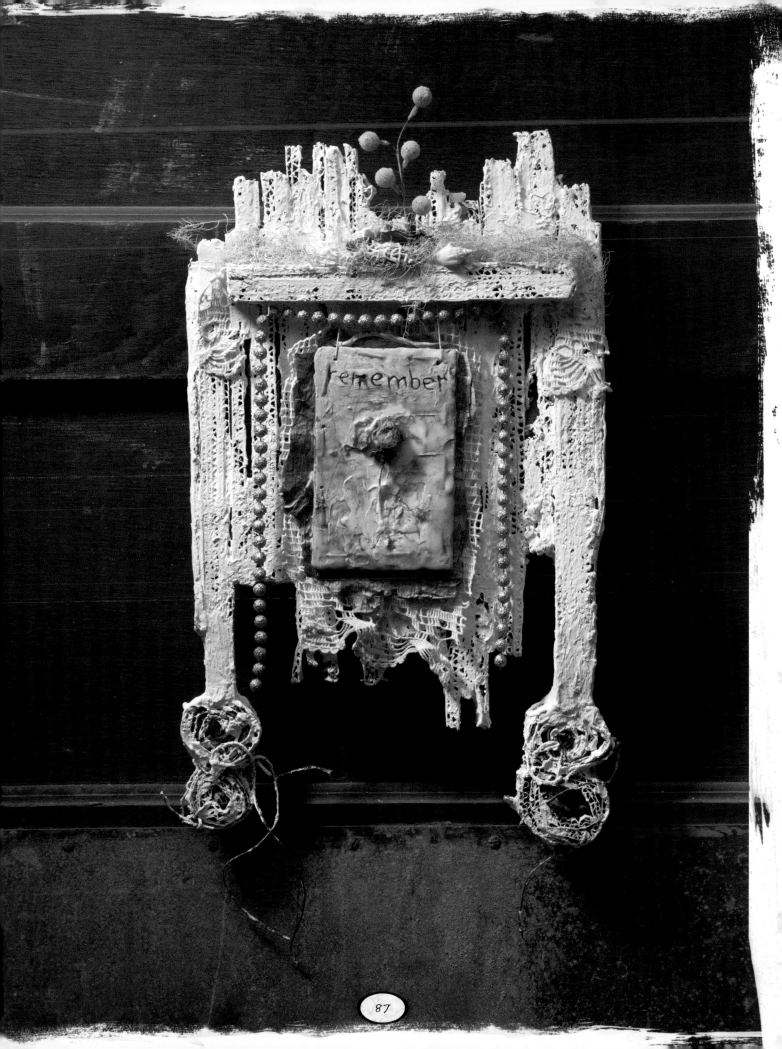

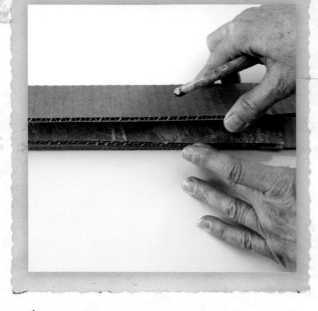

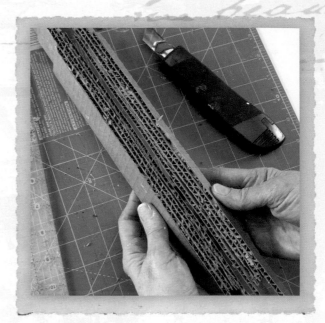

1. Collect several pieces of different cardboard with varying corrugation. With a box cutter, ruler and cutting mat, cut strips 2" x 11"–14" (5cm x 28cm–36cm), with the shorter dimension running parallel to the lines of the corrugation. Use wood glue to adhere them into stacks of four to five pieces, staggering the lengths.

2. When the stacks are dry, cut them into strips that are about ½" (13mm) wide.

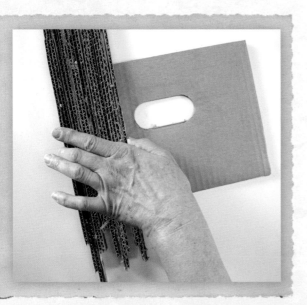

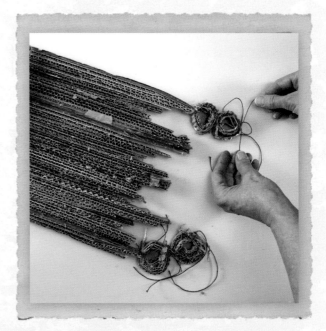

3. Cut a piece of cardboard that has a handle hole (or cut one) that measures 7" x 10" (18cm x 25cm). The handle hole will serve as a hanger, so make sure it is centered near the top. When you have several sets of strips, lay them on the cardboard base, staggering them to get a pleasing design. Glue the sections down to the base with wood glue. When you've got them all glued down, weigh them down with a heavy book to prevent warping until the glue is dry.

4. Glue a strip section across the surface to serve as a shelf. Create four circular pieces by rolling up ½" (13mm) pieces of cardboard coated with glue, and tying them with twine at the ends (I used hemp twine because it comes in a variety of colors). Attach two stacked circles with twine, and then glue cardboard on the back of the circles to cover the center holes. Tie each pair of circles to a bottom corner of the wall hanging with twine.

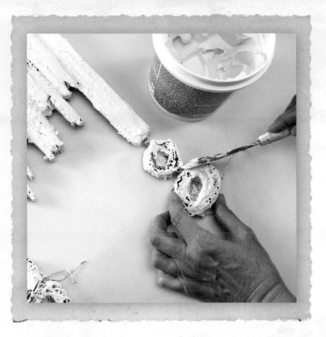

5. Apply joint compound over the entire piece with a putty knife. Leave some of the corrugation showing. Let it dry completely.

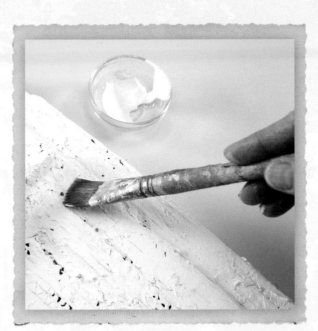

6. Cover the entire surface with a coat of ivory-colored acrylic paint.

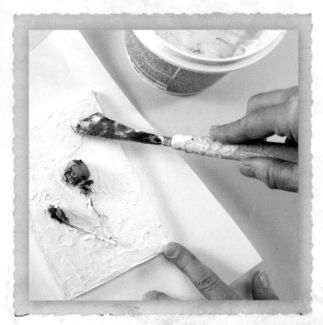

7. Cut a 3" x 5" (8cm x 13cm) piece of cardboard and cover it with joint compound. Embed a dried rosebud or two into the wet compound and let it dry thoroughly.

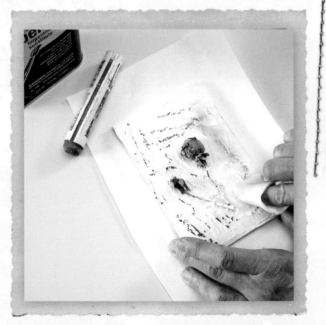

8. Color several areas with a Mauve oil stick and rub with a soft cloth dipped in a little linseed oil to blend.

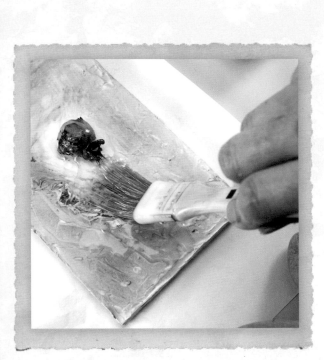

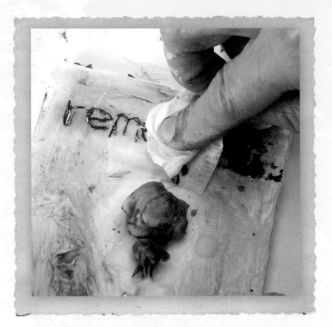

9. Brush on hot encaustic medium and follow up with a heat gun to fuse the wax.

10. With your awl or other sharp incising tool, scribe out a word and rub acrylic paint into the letter impressions, rubbing off the excess with a soft cloth.

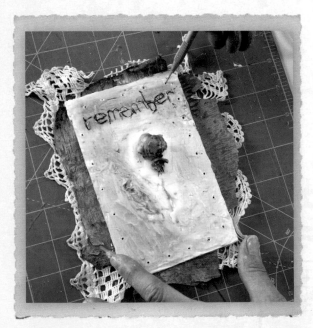

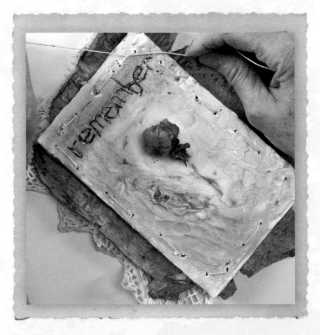

11. Using glue, layer some lace and/or natural element like bark under the little painting. Make holes around the layered piece using an awl.

12. Use waxed linen thread to sew through the holes.

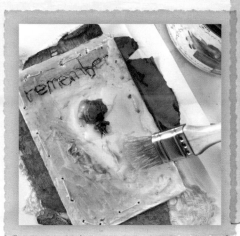

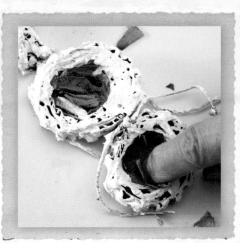

13. Brush another layer of wax over the piece; this time include the lace, bark and the threads.

14. Using an awl or drill, make two holes, spaced 3" (8cm) apart, through the shelf, directly above where the small painting will hang.

15. Glue dried flower petals into the centers of the circles.

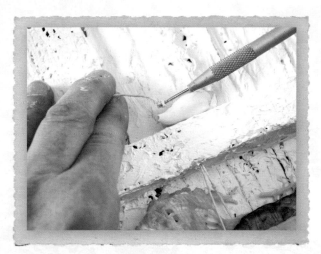

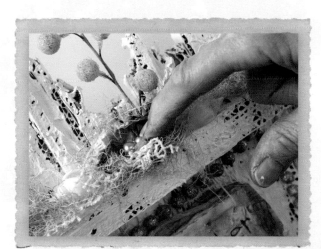

16. Thread a length of waxed linen thread through a hole on the top corners of the painting and run the thread up through the shelf hole. Here, I hid one knot inside of a shell.

17. Add elements such as moss, shells and/or petals to your shelf with glue. I draped a vintage strand of beads on either side of the small painting.

Poetic Purpose

Pay it forward. Leave a piece of found art in a public place, like a park bench, the waiting room in a doctor's office or a bus stop. Attach a note to it that states clearly, "This is an anonymous gift, left here just for YOU."

In Memory of a Loved One

Mica Window and Sewn Book Signatures

I dedicate this book project to my mother. I feel like I could create ten books in her memory and would still only scratch the surface of memories I wish to include. She died a few months after suffering a major brainstem stroke, but time has passed, and now I mostly only remember the ways she lived life BIG.

She loved to sing and would belt out songs in the style of Ella Fitzgerald; she danced the tango in our living room, alone or with a partner—it made no difference to her. When I was a child, she was the only woman I ever saw wear a turban-style winter hat (she was extremely stylish, I realize now), or a turban-wrapped scarf around her hair when she did what seemed to be endless painting and repainting on walls in our house. She drove a little blacktop yellow Rambler, a stick shift that lurched forward every time she changed gears, to the great amusement of my high school friends.

Although I don't have photos of these vivid memories, I feel fortunate to have a few pieces of her clothing, letters and cards, and photographs of her in various stages of her life. I combine what I have with found items that remind me of her, things she may have liked or been interested in, and original artwork. The result is a book—more poem than essay—a visual, tactile and emotional remembrance.

The job of the artist is always to deepen the mystery.

—*Francis Bacon*

Supplies to Gather

- cardboard, some heavyweight and some lighter weight
- box cutter or craft knife
- cutting mat
- straightedge
- white gesso
- paintbrushes
- water container
- acrylic paints, assorted colors, including: Italian Sage, Hunter Green, Titanium Buff
- palette paper
- scissors
- mica
- awl
- alligator clips
- waxed linen thread and tapestry needle
- assorted fabric scraps
- found text
- heavy gel medium
- dried leaf
- paint cloth
- collage ephemera
- paper clips or pins
- sewing machine

Expression Direction

Make a list of people, places, things, activities and events that remind you of a loved one who has died. Use the list as inspiration to create a poem in homage to that person. Use the finished poem at the front of the book as a dedication.

an echo murmured back

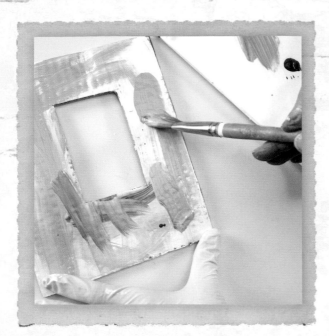

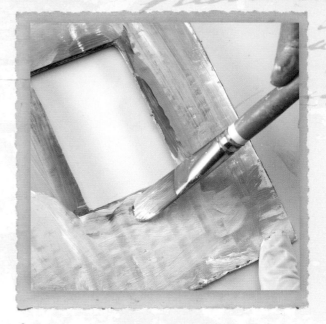

1. Using a box cutter, cutting mat and straight-edge, cut two pieces of heavyweight cardboard and two pieces of lighter weight cardboard, all 6½" x 8" (17cm x 20cm). Cut a window in one of the heavier cardboard pieces, making it off center, so the left (spine) margin is ½" (13mm) wider. First brush gesso on this front side, then add areas of sage green paint.

2. Now add darker green around the window and edges of the front piece. Paint the other heavier piece, the back outer cover, with these same colors.

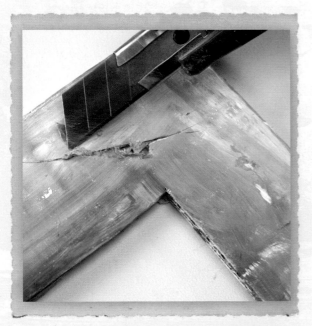

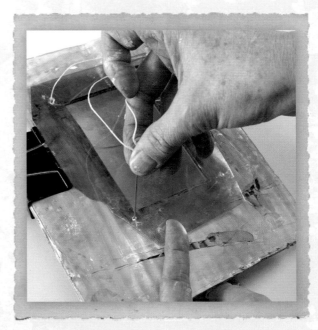

3. Slash and scratch some areas on these pieces using a craft knife, peeling off some of the paper to expose the corrugation.

4. With your scissors, cut a piece of mica large enough to cover the window and extending at least ½" (13mm) onto the edge of cardboard. Lay it over the window and punch small holes into the four corners with your awl, about ¼" (6mm) from edge. Poke one hole at the top center of the window. Use a large clip to hold the mica in place. Thread a needle with waxed linen thread and start pulling the thread up from the back, leaving a long tail. Draw it up through the hole and then back down through an adjacent hole. Tie the tail to the thread from the needle and knot to secure.

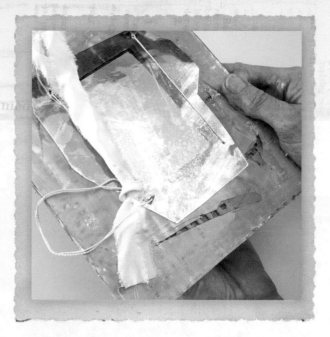

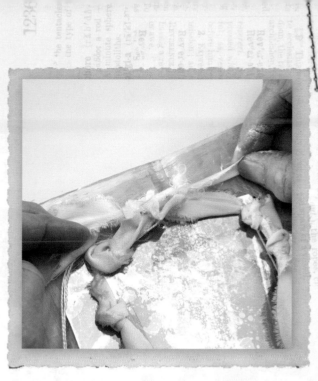

5. Repeat this step with the remaining two holes. Tear fabric into two strips measuring 1" x 18" (3cm x 46cm) (I'm using silk here). Tie knots on all four ends. Position one strip along a side and bring the threaded needle up through the bottom hole. Wrap it around the knot and bring the needle down through the same hole.

6. Twist the fabric strip a bit and bring your threaded needle up through the top hole above it and back down into the same hole. Do the same on the opposite side. Tie the two strips together in the center at the top and bring the knotted thread up through the center hole, wrap it around the bow, and then bring it down through the same hole. Knot the thread on the back.

7. Glue a piece of book text down onto one of the lighter cardboard pieces using gel medium, making sure it will be completely covered by the window. Glue a leaf down so it will be centered in the window.

8. Paint around the leaf with Titan Buff to tone down the text and blend it in by rubbing with a cloth.

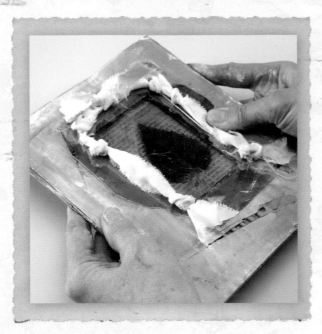

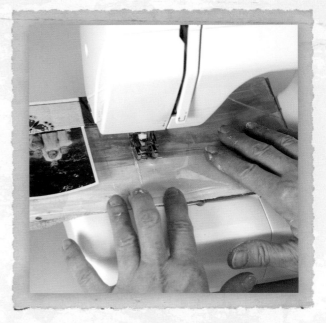

9. Glue the two front cover layers of cardboard together and the painted back cover to the other piece of lightweight cardboard. Weight them down with a heavy book to prevent warping until the glue is dry.

10. For the book pages, I find it easiest to work on page spreads before creating the signatures. Paper clip or pin fabrics, papers and ephemera to a base made of paper or fabric. Start by sewing around the perimeter of the piece, then go back and secure loose edges in the interior areas. Here I am sewing a fabric pocket to hold a family photo.

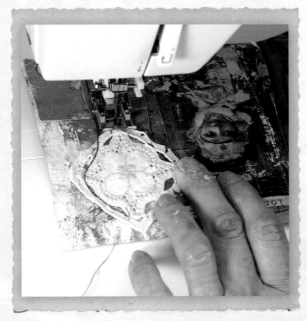

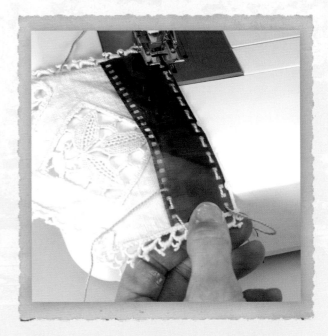

11. Include bits of clothing, letters, photos and other items that inspire memories.

12. Some elements can be sewn together before attaching them to the spread. Here, I am creating a pocket with lace from a family table runner and a negative strip containing family photos.

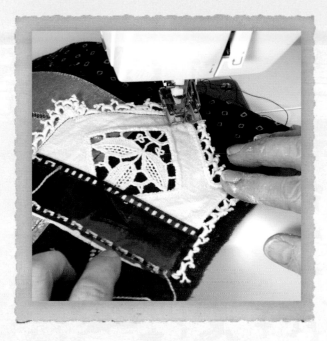

13. Attach the finished element to the page.

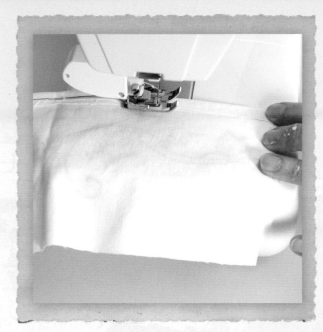

14. To bind completed spreads into a book, create a spine using a piece of old tablecloth or any fabric that holds memory or association for you. Cut a piece the length of the book and wide enough to accommodate your signatures plus a little extra that will overlap the front and back covers. Here, I am using three layers of fabric, 5" x 8¼" (13cm x 21cm). Arrange page spreads into two to three signatures.

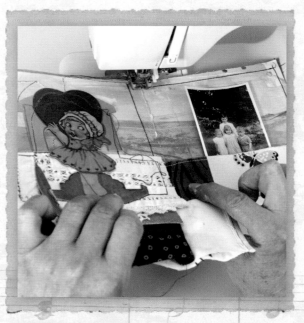

15. With spine fabric wrong-side up, line up the middle signature in the center of the fabric spine and sew down the middle of the spread, attaching both layers. To add the next signature, butt it up against the first one and sew down the signature fold again.

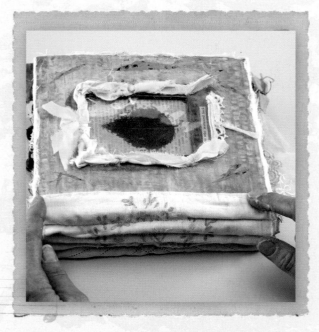

16. Sew down all the signatures, alternating from one side to the other of the center signature. Hand sew a running stitch on the outside edges of the fabric spine, turning in raw edges. Put down a line of glue (just enough) to attach the spine to each of the covers.

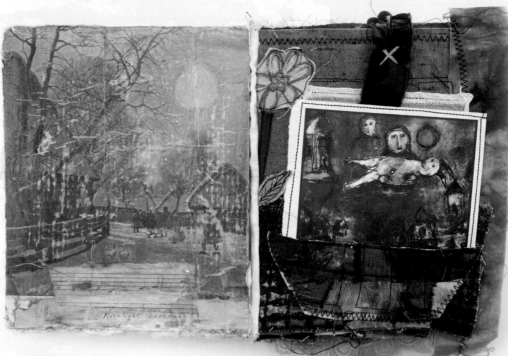

HOME

The image on the left represents the country culture my mother grew up in. On the right, I sewed a boat out of fabric. It is holding a scaled-down print of one of my paintings, "Carry Me Home," symbolizing her spiritual journey home at the time of her death.

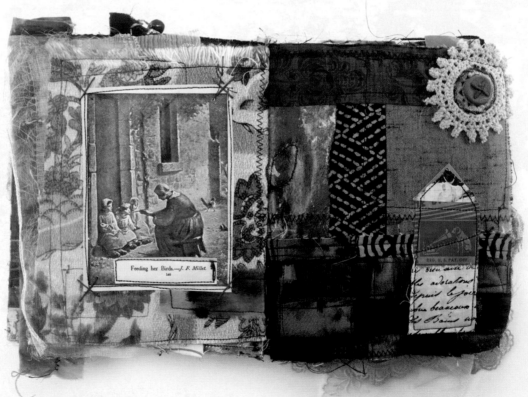

A Giving Spirit

Here, I combined fabrics, lace, buttons and paper. On the left, I framed a favorite book illustration with vintage fabrics, sewing everything together with "messy" stitching—my favorite kind. I created a pictorial collage on the right, indicating my mother's love of music by including the RCA emblem inside the sewn house.

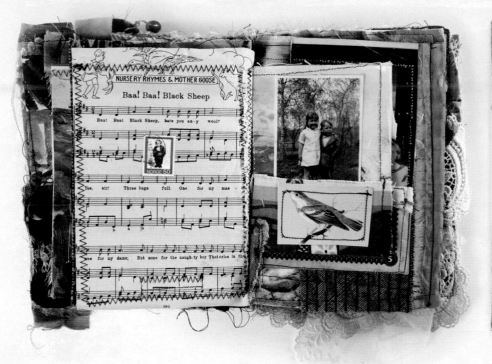

Top left: **Singing to the Sheep**
Top right: **Her Life Made a Lovely Imprint**
Bottom: **She was Born to Burn Brightly**

I used combinations of photographs, music and ephemera to translate the feeling of my mother, the stories I'd heard her tell me of her childhood, as well as first-hand memories I have of her. I'm not as interested in showing the viewer true artifacts as I am with infusing the pages with hints of her essence—ethereal and intangible.

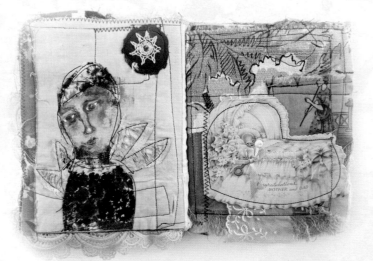

Poetic Purpose

Visit a nursing home or assisted-living facility in your area. Ask the staff to recommend someone who rarely receives visitors and adopt that person as "family," visiting them on a regular basis, listening to their stories, looking through old photos, reading to them, finding out about their favorite things, etc.

Papier Mâché Doll

Sculpting Clay and Sewing a Doll Form

You'll have an opportunity to play with several different media while creating this little doll. The head is sculpted using papier mâché clay and painted with acrylics and colored pencil accents. The clothing is sewn from felted wool sweaters, embellished with simple embroidery stitches and topped off with a piecework poetry apron.

You may want to change the shape of your doll's head or sculpt more distinctive facial features with the clay. I chose to keep the armature simple, preferring the two-dimensional look of a flat painting for the face.

I made the poetry apron by sending the tattered fabric through my vintage typewriter (I love to find ANY excuse to use my vintage typewriter!). You'll need to first iron your fabric pieces onto the shiny side of a piece of freezer paper, and then roll it on through just like a normal piece of typing paper. When you're done typing, peel off the freezer paper and voilá, text on cloth! The typing mistakes . . . well, they just give the piece more charm.

Creativity is the quality that you bring to the activity that you are doing. It is an attitude, an inner approach—how you look at things. . . . Whatsoever you do, if you do it joyfully, if you do it lovingly, if your act of doing is not purely economical, then it is creative.

—Osho

Expression Direction

Write a poem from the point of view of a doll. Possible things to write about would be what her world looks like from where she sits, her hopes and dreams, what she looks like, does she like being a doll, does she have a human to love her?

Supplies to Gather

- newsprint or similar weight paper
- cork (such as a wine cork)
- masking tape
- batch of papier mâché clay (see recipe, page 68)
- waxed paper
- rolling pin
- drill
- annealed baling wire and wire cutters
- narrow neck jar or bottle
- assorted pieces of vintage text
- Elmer's Glue-All
- small bowl
- white gesso
- paintbrushes
- water container
- rag
- pencil
- acrylic paints: Titanium White, Payne's Gray, Quinacridone Crimson, Quinacridone/ Nickel Azo Gold, Carbon Black
- palette paper
- white gel pen
- colored pencils
- floral foam
- craft knife
- serrated knife
- round wooden base
- fabric scraps, including some felted wool sweater scraps
- small piece of stiff interfacing
- sewing machine
- embroidery needle and assorted embroidery thread
- white paper
- stuffing material
- chopstick
- fabric (muslin or silk) printed with poetry or text
- freezer paper
- iron and ironing board
- typewriter
- ruffled fabric
- snap tape
- pearl buttons

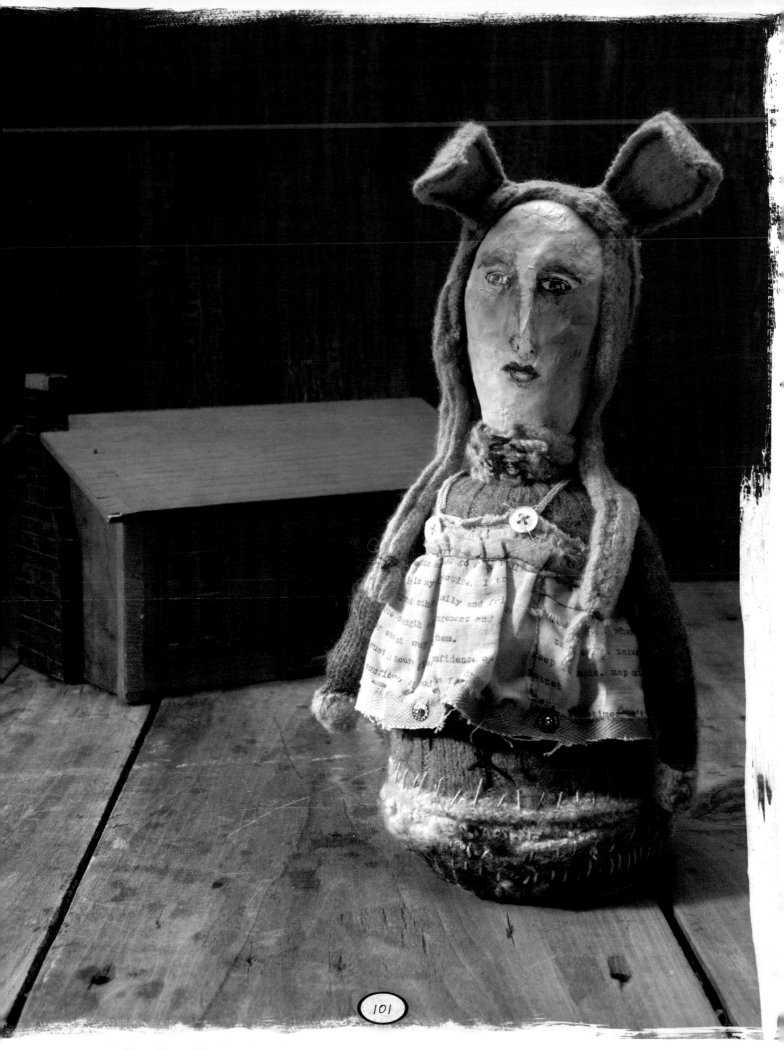

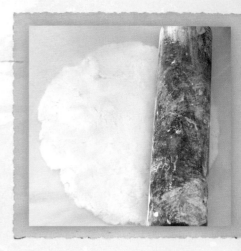

1. Start by crumpling up a piece of newspaper and push a cork into the bottom of it.

2. Shape the crumpled paper into an oblong head as you wrap it with masking tape.

3. Roll out some papier mâché clay between two pieces of waxed paper to about 1⁄8" (3mm) thick.

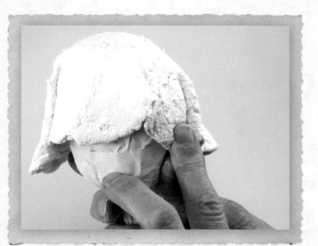

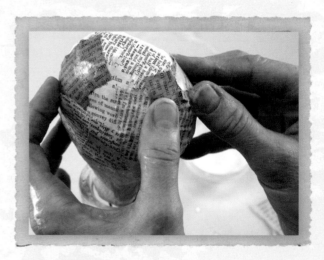

4. Drape the flattened clay over the masking tape form. Smooth the clay with a wet finger as you spread it over the entire form. Bake it on very low heat or let it air dry overnight.

5. Drill a hole horizontally across the neck and push through a 6" (15cm) piece of baling wire. With an equal length of wire sticking out of each side, bend the wire down parallel with the neck and twist the two pieces together. Insert the wire into a narrow neck jar or bottle to make it easier to work on for the next step. Dip small pieces of vintage text into a pan of diluted Elmer's glue (one part water to one part glue), and attach them to the surface of the head, smoothing each piece to get out all the air bubbles and overlapping various texts to add interest.

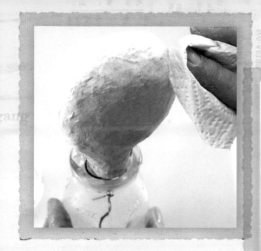

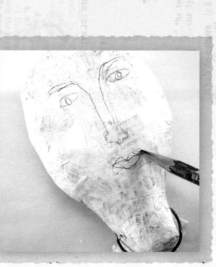

6. When dry, paint the entire surface with diluted gesso. You still want to see a hint of the text. Wipe off the excess gesso with a rag.

7. When dry, sketch the facial features using a pencil.

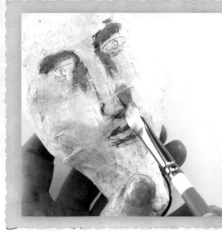

8. Start painting the dark areas of the face first, adding and blending in lighter tones.

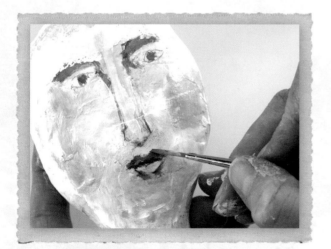

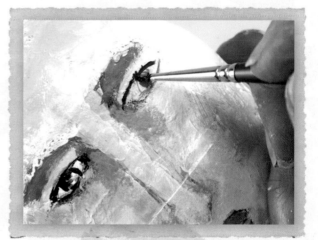

9. Add shading on the cheeks, chin and other areas. Fill in darker details on the eyes and add definition to the nose and lips.

10. I like to use a detail brush loaded with black paint on the darks of the eyes.

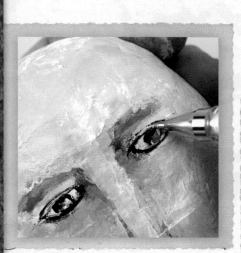

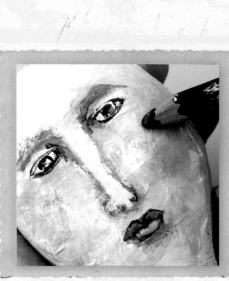

11. Drawing a fine line of white over the eyes with a gel pen makes the eyes stand out.

13. Cut a piece of floral foam for the body form. On one end, trace the end of a cork.

12. Colored pencils can add final shading around eyebrows and along the nose; also to add concentrated color to the cheeks.

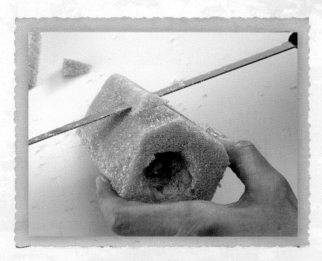

14. Use a craft knife to carve away the foam where the neck will be inserted.

15. Use a serrated knife to round out the form.

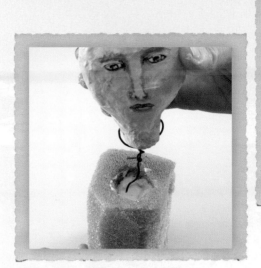

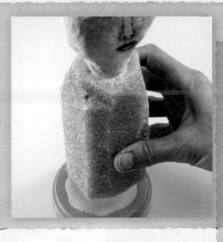

17. Glue the bottom of the foam to a round wood base.

16. Put a generous dollop of glue into the hole, and then push the wire on the head form into the hole, burying the bottom of the neck in the foam.

18. Cut two bunny ear shapes from a piece of felted sweater. Cut a piece of stiff interfacing just a bit smaller and sandwich it between the two sweater pieces. Repeat this step for a second ear.

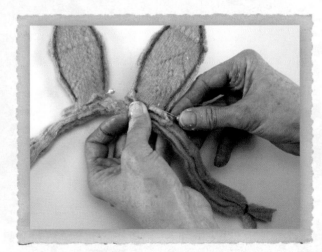

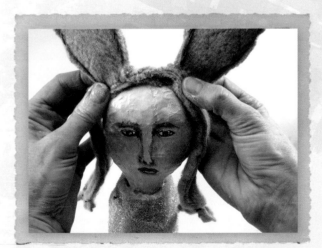

19. Use a sewing machine to attach all three layers of each ear together along the outside edges. With contrasting thread and a needle, hand-embroider an outline stitch along the edges of the ears. Cut strips from the bulky seams of the same sweater used for the ears, and piece them together with the ears to form a headband. On the ends of the sweater strips, wrap embroidery thread around a few times and knot to make ties. Pin the ears to the long piece, sandwiching them between the layers and arranging them so they will be evenly positioned on the head.

20. Handstitch the ears to the tie piece. The front layer of the ears and the back layer both need to be stitched to the tie. Glue the piece to the top and sides of the head.

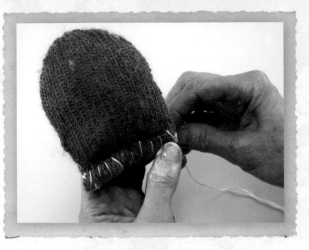

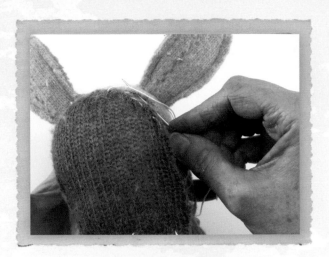

21. To create the back of the hat, shape a piece of paper around the back of the head and crease the paper where it meets the headband. Draw out the paper pattern. Using this pattern, cut two pieces of contrasting sweater material and stitch them together, leaving the bottom open. Turn right-side out and lightly stuff with stuffing material. Handstitch the opening at the bottom closed.

22. Handstitch the back piece to the headband piece along the edges so they are now both firmly attached to the head.

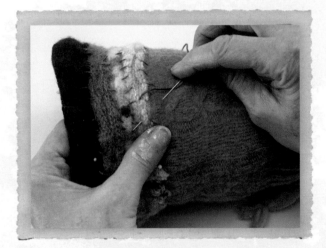

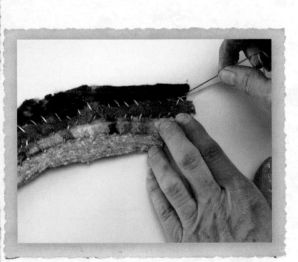

23. Cut four long seam strips from assorted sweaters and whipstitch them all together using embroidery thread.

24. Cut a section of felted wool from a sweater sleeve in a complementary color. With the cuff end acting like a turtleneck, pull the sweater section down over the head and body of the doll. Whipstitch one edge of the strip fabric to the bottom edge of the sweater sleeve.

Felted Wool

In case you don't know how to felt a sweater, here's how—it's easy. Start with a recycled sweater that is at least 80% wool. Wash it in the washing machine on the hot cycle, and dry in a hot dryer.

If you find you like working with felted wool, you'll end up having plenty of small sweater scraps leftover. I keep mine all together in a big basket to use for trims and accents, I seem to find a use for everything, down to the bulky seams.

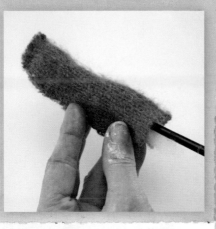

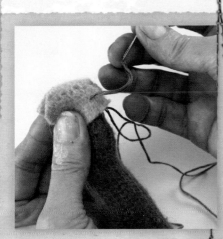

25. Draw a simple arm pattern onto paper, similar to the one shown here. Fold a piece of sweater fabric in half and place the straight edge of the arm pattern along the fold. Cut off excess fabric around the edges.

26. Handstitch along the edges, leaving the bottom open. Poke stuffing into the armhole using a chopstick to push stuffing to the far end.

27. Cut out two small pieces of fabric for a mitten, using the curved shape of the hand as your pattern guide.

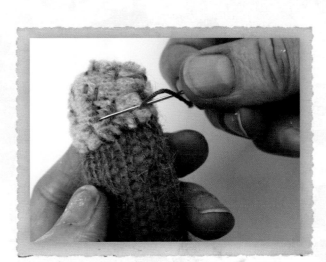

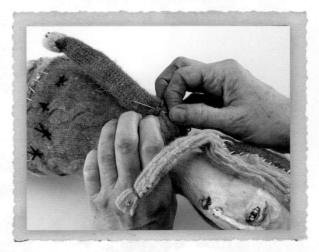

28. Sew the mitten to the arm using many little stitches.

29. Repeat this process for the second arm. Add additional embroidery to the sweater body, if you like. Here I embroidered little brown stars. Handstitch the arms to the sides of the doll, attaching them to the top of the sweater body as shoulders.

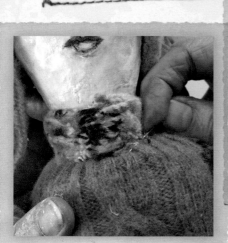

30. Add a small section of sweater fabric around the neck for a collar, attaching it to the body at the top edge.

31. Type poetry or prose onto assorted small scraps of muslin and silk. (Use the method described in the introduction on page 100.) Sew them together in a long band, and gather the top edge so it fits around the doll. Sew a narrow ruffle out of similar fabric or find a ruffle in a piece of clothing that you can cut out and repurpose like I did here, the same width as your text piece.

32. Sew the gathered text fabric to the top of the gathered ruffle. Attach a strip of snap tape along the bottom edge with embroidery floss.

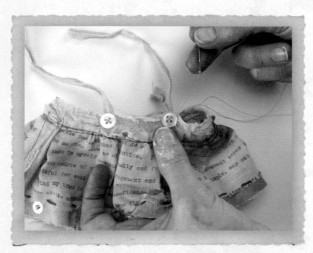

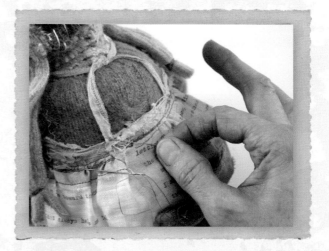

33. Cut thin strips of fabric for straps and attach them to the top of the apron with pearl buttons.

34. Bring the straps up over the doll's shoulders and tie at the back of the neck. Stitch the loose strap ends down at the top of the apron back. Bring both sides of the back apron together and stitch closed.

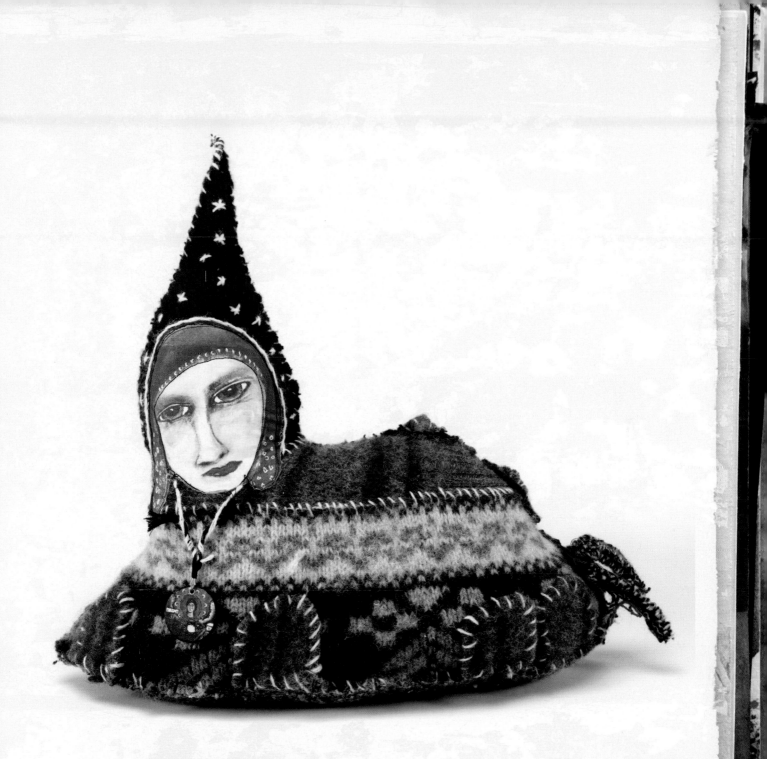

Not Your Average Fat Cat

Made with hand-stitched felted wool sweaters, embroidery stitches and a hand-painted face,
this whimsical cat has a secret pocket in the back that holds a small visual journal.

The Girl in the Thinking Cap (left)
I Will Carry Your Heart (right)

The Girl in the Thinking Cap *has a face, arms and legs that are muslin and hand-painted with acrylic paints. Her body and custom-made cap are made from soft, felted wool.*

The doll on the right is made by painting solid front and back pieces with oil sticks and embellishing each side with stitching before sewing together and stuffing.

Garden Muse

The face is painted with acrylics and colored pencil. The body is pieced with a variety of recycled bits of clothing and trims.

Poetic Purpose

Create a doll to donate to a child who is temporarily living in a local battered women's shelter. Pin a tiny booklet to the doll telling her story—her name, where she comes from, about her family, her history, her interests, etc.

Tactile Poetry Fabric Art

Image Transfers on Recycled Fabrics

The following project and project variations combine some of my favorite things: recycled bits of fabric and trim, fabric transfer, painting on fabric, sewing on fabric and fabric embellishing. There is no need for a pattern; just start with any size fabric for your base and add layers to it until it feels finished. I like the freedom of working without pattern boundaries as well as the continuous creative challenges that arise when I work in this way. Not having the story beforehand, not having a theme to go by, makes this more about trying out ideas in new ways, listening to and following the "what if I do this . . ." voice in your head whenever you hear it. By following that voice, you will discover the clues you need, one by one, to lead you to each new step in the process. The block may start out being the center of a larger growing piece that expands on some or all of the sides. At some point you may find that you like your small block just the way it is, raw edges and all.

Then comes finding a creative way to display it. If you have several small blocks made, you may want to sew them together into a larger quilt, using customized fabric borders to make it fit together, or bind your collection together into a soft fabric book.

> The creative person is willing to live with ambiguity. He doesn't need problems solved immediately and can afford to wait for the right ideas.
>
> —Abe Tannenbaum

Supplies to Gather

- freezer paper
- Pentel pastel dye sticks for fabric (or fabric crayons)
- smooth, light-colored fabric
- iron
- sewing machine
- scraps of fabric, trim and lace
- pencil
- fabric scissors
- fabric glue
- walnut ink
- water container
- paintbrushes
- fabric pens
- embroidery thread and needle
- poem or words typed onto fabric (optional)

Expression Direction

Start a collection of recycled fabric, lace and trim scraps. Include bits of recycled clothing that have sentimental significance or interesting patterns, colors or textures. This might include clothing labels, rows of buttonholes or buttons, interesting pockets, embroidered areas, places with patches or holes, frayed areas, zippers, puckers or gathers, lace, trim, fabric from bridal wear, linen table-cloths and sheer curtains. Spread out your collection in front of you and write what you know about them in the form of a list or poem.

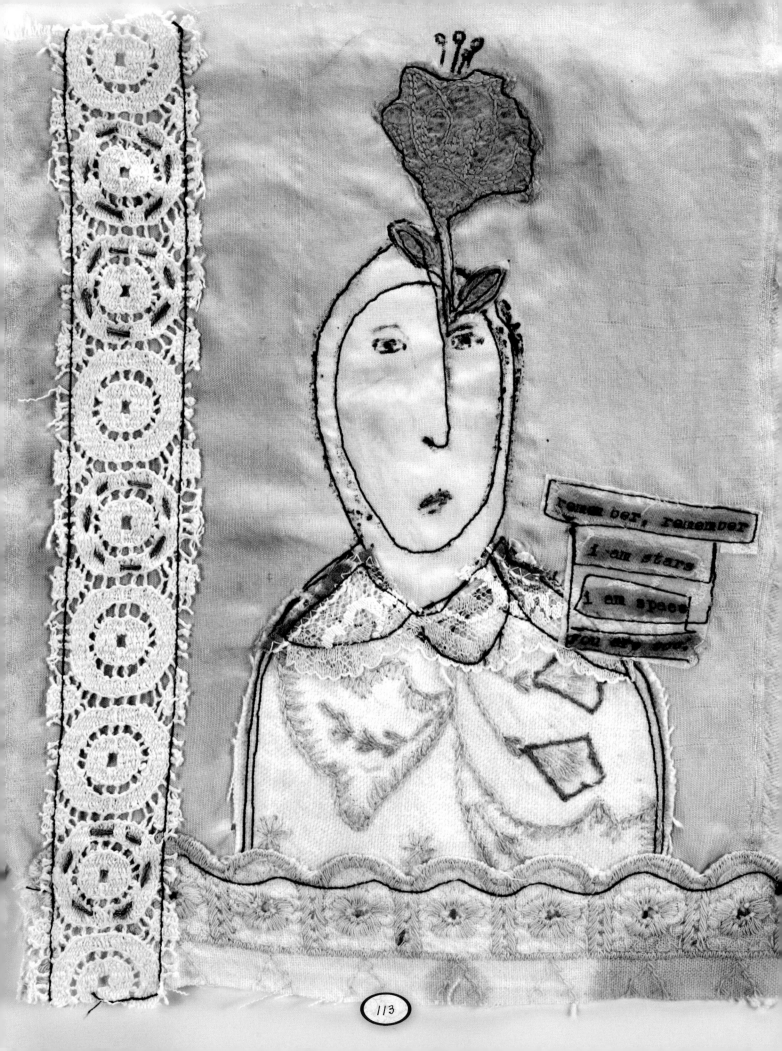

remember, remember
i am stars
i am space
you are good

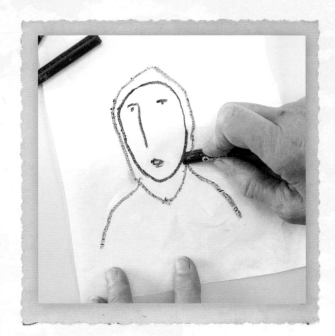

1. Create a drawing on the shiny side of a piece of freezer paper using fabric dye pastels or fabric crayons. Keep in mind that your drawing will be in reverse after it is transferred.

2. Place the freezer paper, drawing side down, on a smooth, light-colored piece of fabric and iron the back.

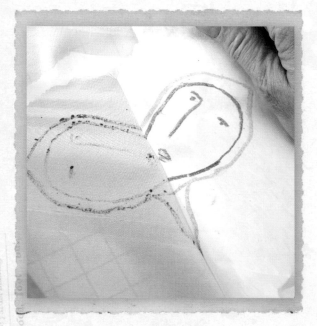

3. Peel the freezer paper up.

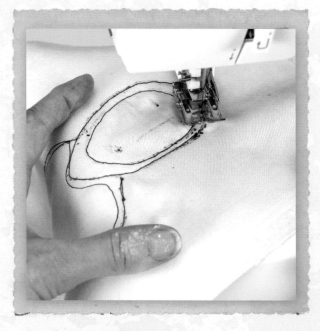

4. Use a sewing machine to sew over the lines of the drawing.

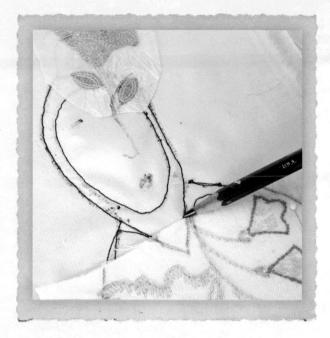

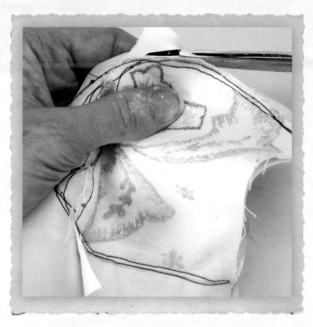

5. Arrange your composition by laying down and auditioning various fabric pieces, adding additional lines with pencil if needed.

6. Sew additional seam lines, connecting each new fabric to your base fabric as you design your composition. Trim excess fabric close to the sewing lines.

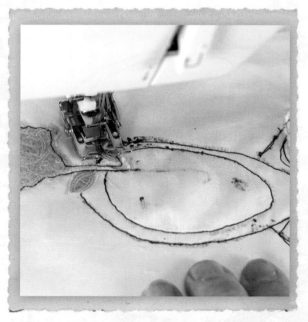

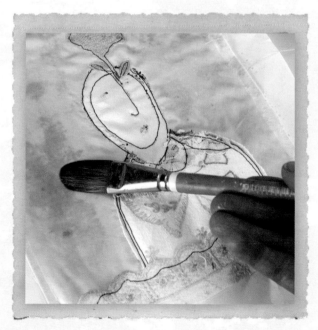

7. To add intricate elements, cut them out and tack them to the base fabric with a dab of fabric glue before sewing them on.

8. Here I added a wash of diluted walnut ink to the light background to make the figure stand out.

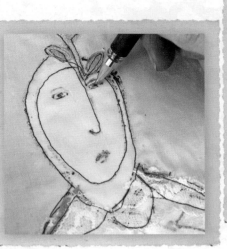

9. Continue adding pieces of trim and other finishing elements, as desired. Use additional lines of sewing to add lines and texture. Colored fabric pens are good for defining facial features and other accents.

10. Handstitched details, like the embroidering here on the lace, can can add just the right touch.

11. Finally, add a poem or any words you wish to include. Here, I am sewing on words that I typed onto fabric.

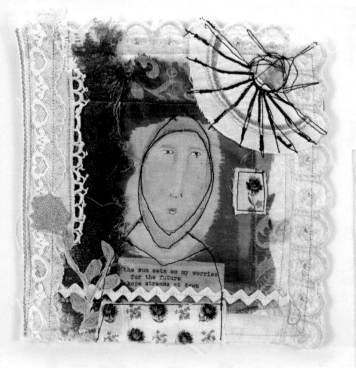

Hope Streams at Dawn

I used a fabric crayon and freezer paper to transfer the face and designed the body using sewing lines and bits of fabric. I painted walnut ink in the area of the face extending out so it felt like light streaming on her. I used green-pigmented walnut ink to dye the interior area of the fabric and trim, and sewed on an embroidered flower I cut off a discarded silk blouse. I wrote the poem after the piece was finished.

Poetic Purpose

Organize a group of people to make a collaborative quilt for a mutual friend who is going through a health issue, a personal crisis or just needs to be reminded about how special they are. Each person sends you a block they have sewn or painted as well as a note for the recipient. You arrange the blocks and sew the finished quilt as well as a fabric pouch to put the notes in.

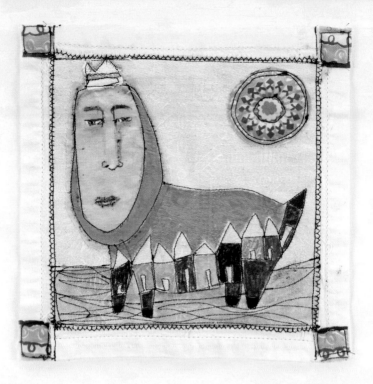

He Carried His Home with Him Wherever He Went

For this one, I cut out the face after I did the fabric crayon transfer and sewed it on a base fabric that I had rolled white paint on over textured wallpaper and then printed onto. I sketched a body and colored in the houses and body with paint markers. I outlined with stitches and added pieced borders.

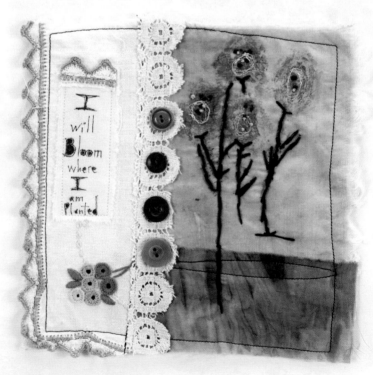

I Will Bloom Where I Am Planted

I created the flowers by scribbling red fabric dye crayons onto freezer paper and ironing them onto the gold silk. I used machine stitching and hand embroidery, and layered various fabrics and trims.

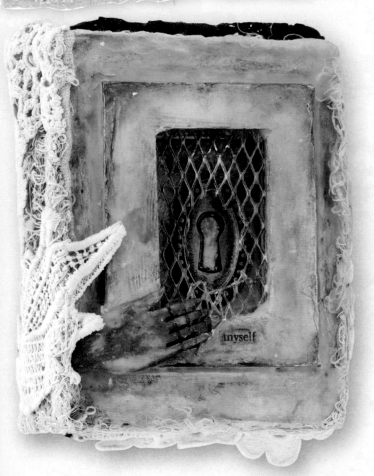

I Hold the Key

The little cardboard book is small but chunky. For the cover (left), I used a recycled tiny wood door, cut away some of the screen and glude in a keyhole. The spine is covered with vintage lace and the small hand is made of bone. The title of the spread below is "Watching for Miracles."

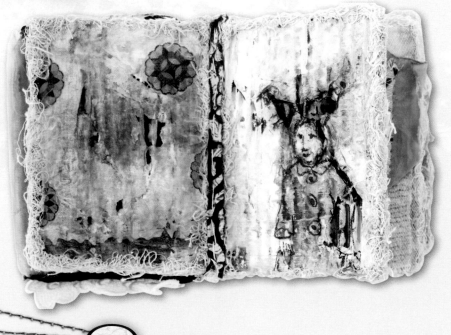

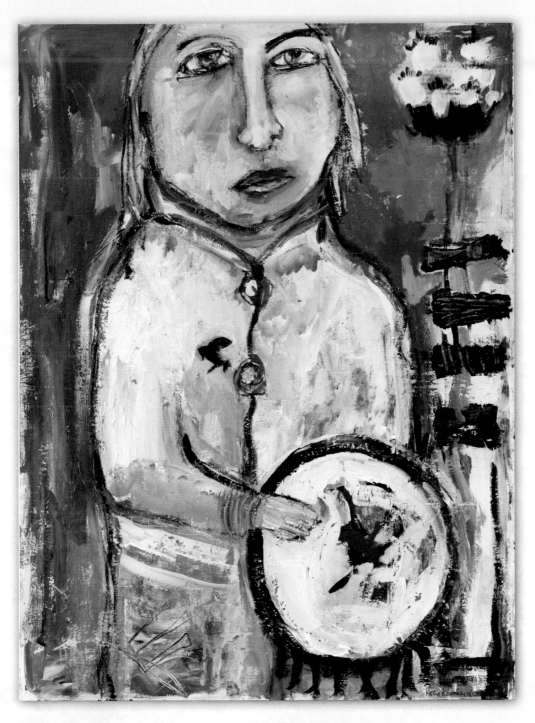

She Walked to the Beat of Her Own Drum

I started this project by painting the face and then the rest was revealed to me little by little. Although I had no intentions of the sort at the time, a couple years after painting this, I made my own drum and find drumming to be a meditative and relaxing activity.

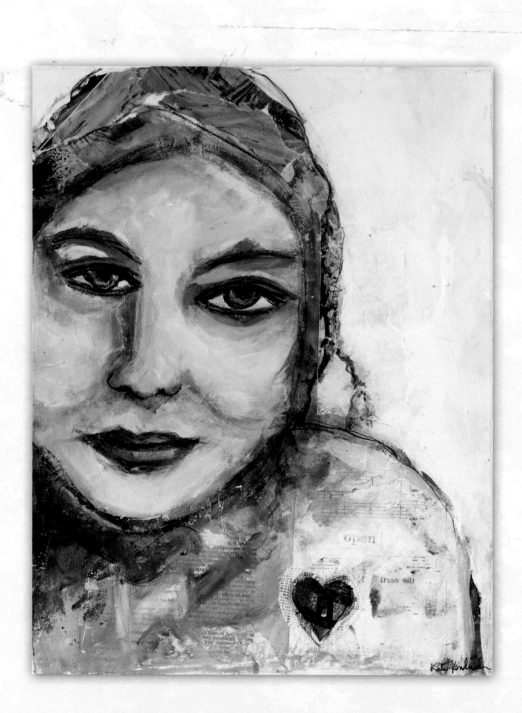

Motherhood

This piece depicts how becoming a mother (and now grandmother) has opened my heart in unimaginable ways, not only to my own children and grandchildren, but to Mother Earth herself and all her inhabitants..

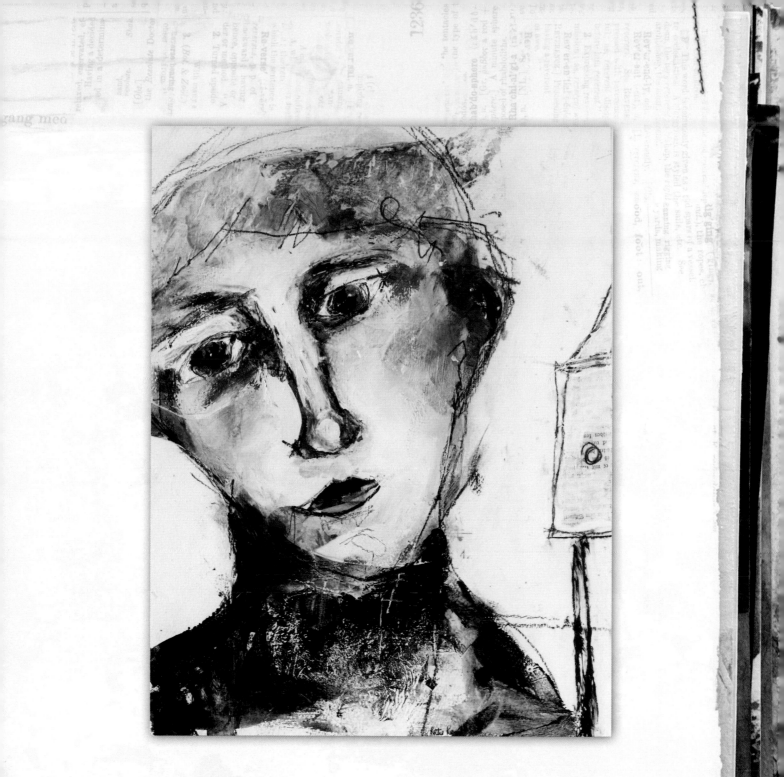

The Song

*I created this painting using the process I describe in the Every
Face Tells a Story project (page 14).*

16 15 14 13 12 5 4 3 2 1

www.fwmedia.com

Distributed in Canada by Fraser Direct
100 Armstrong Avenue
Georgetown, ON, Canada L7G 5S4
Tel: (905) 877-4411

Distributed in the U.K. and Europe by F&W Media International
Brunel House, Newton Abbot, Devon, TQ12 4PU, England
Tel: (+44) 1626 323200, Fax: (+44) 1626 323319
Email: enquiries@fwmedia.com

Distributed in Australia by Capricorn Link
P.O. Box 704, S. Windsor, NSW 2756 Australia
Tel: (02) 4577-3555

Editor	Tonia Davenport
Designer	Ronson Slagle
Production Coordinator	Greg Nock
Photographers	Christine Polomsky, Richard Deliantoni
Photo Stylist	Jan Nickum

dedication

Dedicated to you, the Reader, and to the Infinite Source of creativity you embody.

acknowledgments

To my husband, Walter, thank you for believing in me, encouraging me and supporting me in the countless ways you do. I wouldn't have been able to do this without you cheering me on.

To my daughters, Heather and Marissa, your abiding presence in my life brings out the best in me.

To my mother, for living the joy and passion of a creative eccentric; I didn't appreciate that about you when I was a child or teenager, but I treasure those memories now.

To those at North Light Books for believing in me, including Ronson Slagle, Christine Polomsky and others on my creative team for their valuable artistic contributions.

To Tonia, my editor, who gently persuaded me that I did have something to say and ever calmly guided me through all the channels, dips and turns along the way.

To Bernie Berlin, my first art mentor, for your encouragement and support when I was a fledgling artist.

To all of my spiritual teachers, mentors and fellow travelers on the path.

To my guides, always supportive and faithful to me and to the manifestation of this book. You are a source of unwavering love and light for which I am eternally grateful.

Resources

Supplies

Golden Artist Colors, Inc.
www.goldenpaints.com
fluid acrylics, gel mediums, gesso, Acrylic Flow Release, iridescent paints

PanPastel
www.panpastel.com
pastels

Ranger Industries, Inc.
www.rangerink.com
Claudine Hellmuth Studio acrylic paint

Book Recommendations

The Zen of Seeing: Seeing/ Drawing as Meditation

by Frederick Franck

Writing and Enjoying Haiku: A Hands-On Guide

by Jane Reichhold

Life, Paint and Passion: Reclaiming the Magic of Spontaneous Expression

by Michell Cassou and Stewart Cubley

Art from Intuition: Overcoming Your Fears and Obstacles to Making Art

by Dean Nimmer

Acrylic Revolution: New Tricks and Techniques for Working with the World's Most Versatile Medium

by Nancy Reyner

Trust the Process: An Artist's Guide to Letting Go

by Shaun McNiff

The Artist's Way

by Julia Cameron

The Confident Creative: Drawing to Free the Hand and Mind

by Cat Bennett

Make Animal Sculptures with Paper Mache Clay

by Jonni Good
(This book features the papier mâché clay recipe that I used for a couple of projects.)

Index

Index (continued)

about Katie Kendrick

Katie Kendrick, a self-taught mixed-media artist, was born and raised on the South Dakota prairie, where fierce winds sent sagebrush tumbling, wild asparagus grew along the side of the road and the call of the red-winged blackbird made a lasting impression in her memory.

Her adventurous spirit and love of nature led her to hit the open road just days after high school graduation. For the next couple years, she traveled around the western United States, hiking in the mountains, soaking in hot springs, camping in nature and meeting all types of people.

Soon after that, Katie met her husband, and her focus changed to raising a family and making a home in the Northwest countryside. Her interest in spirituality and higher living, by way of meditation, teachers and introspection, continued to be a constant and growing source of discovery, strength and joy, eventually leading her to her passion—painting.

Katie teaches mixed-media workshops nationally now, and her artwork and articles have been featured in several books and magazines. She lives along the banks of the Tahuya River, surrounded by the state forest, with her husband, three dogs and a persnickety old cat.